The Best Dog

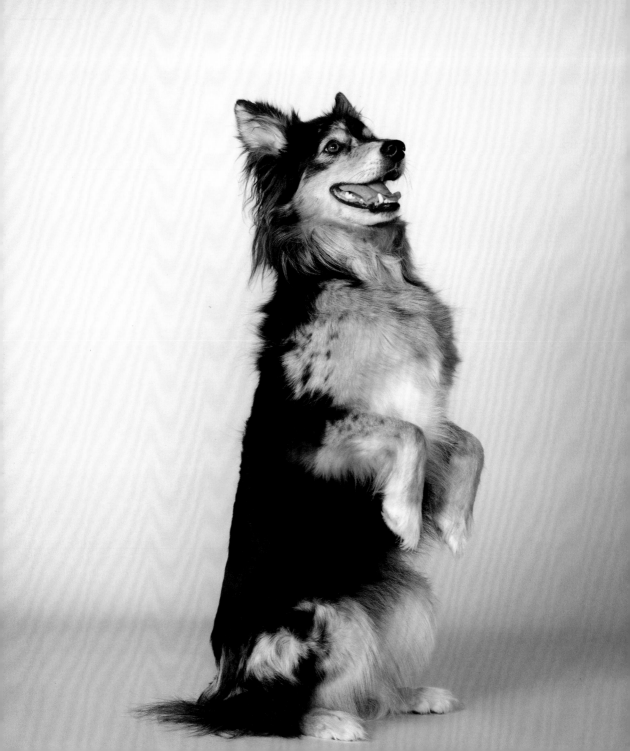

The Best Dog

Hilarious to
Heartwarming
Portraits of the
Pups We Love

Aliza Eliazarov
with Edward Doty

TEN SPEED PRESS
California | New York

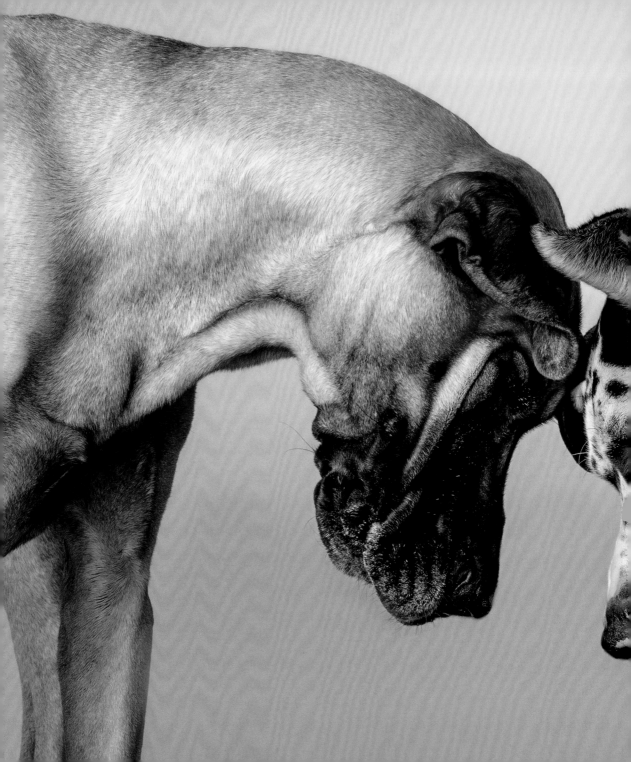

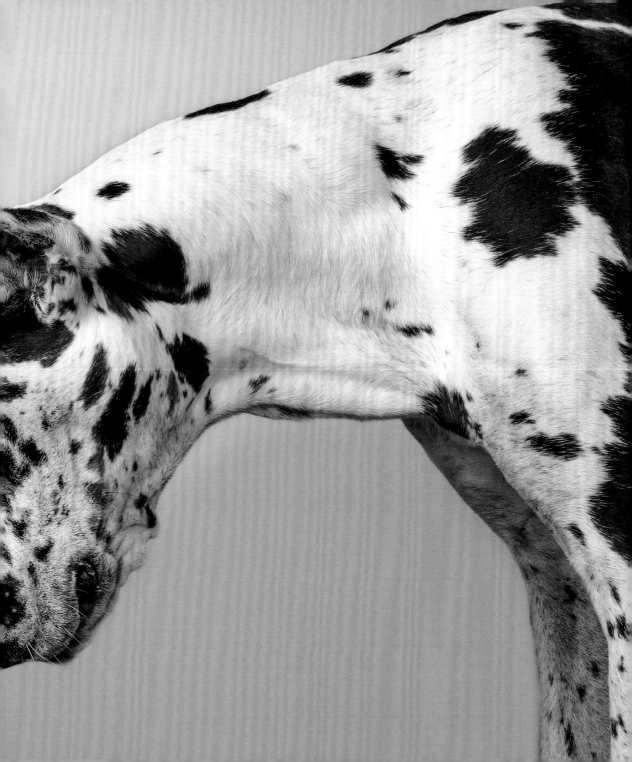

For Ducky

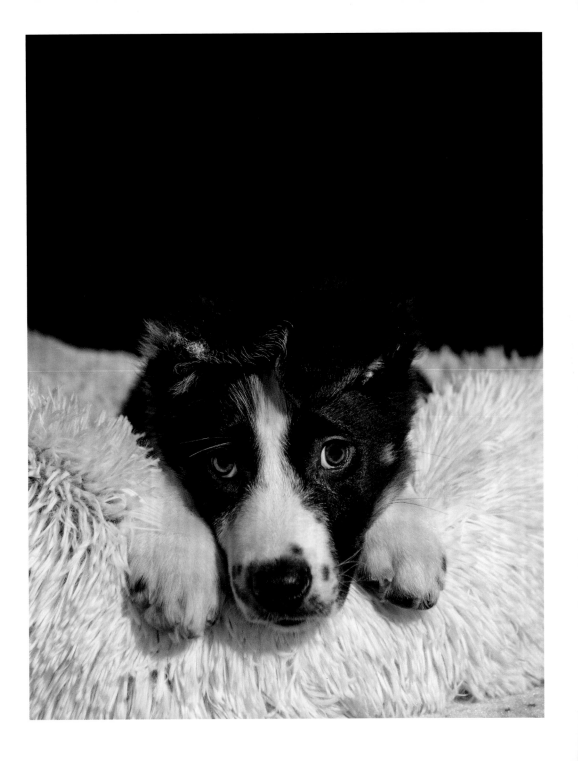

Contents

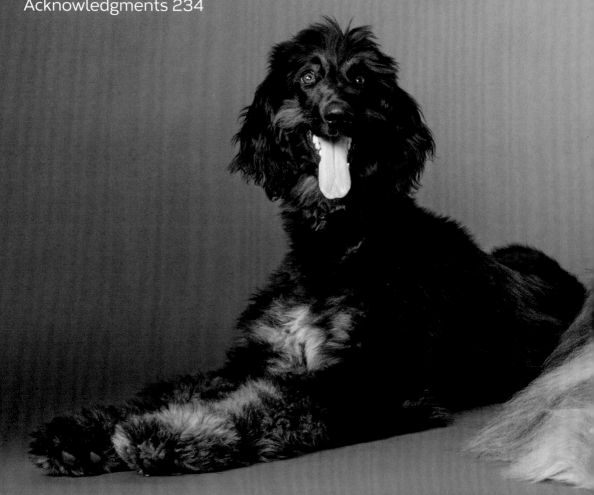

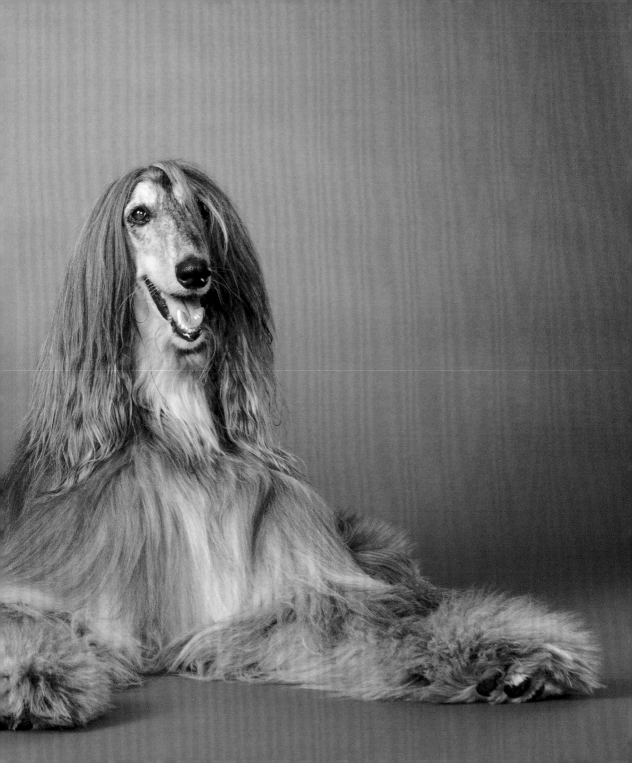

Introduction

What's better than being greeted at the end of a long day by a butt-wiggling, tail-wagging kiss monster? When you're struggling—and even when you're not—what brings you more comfort than a good couch cuddle with your dog? Smelling your dog's Frito feet is better than any aromatherapy. Their facial expressions can melt your heart or crack you up. And somehow, this pup who lacks employment or a five-year plan makes you feel safe in the world. On walks together, you pause to gaze at the clouds and the birds. You feel the sun, wind, and rain. Heck, you might even chat with a neighbor or make a new friend. Those walks aren't just good for your pet; they're good for you, too.

Your buddy has a complex, unique personality with their own quirks, fears, and fetishes: refusing to poop when it rains, hoarding dirty socks, humping pillows, barking at the vacuum, and drooling for whipped cream. How magical it is to know another creature so well!

Caring for a dog has taught you compassion, responsibility, and patience. You love your dog so much that you pick up their hot poop and carry that stinking bag around until you can find a trash can. You sweep up the never-ending fur that covers your floors while your pooch slobbers on the new couch. Not once have they offered to clean or pay rent.

We photographed more than a hundred dogs for this book. Talking with folks about the project, we'd hear again and again, "You need to photograph my dog! I have the best dog!" We heard amazing stories, rescue tales, and heartwarming anecdotes.

Photo shoots were a collaboration between photographer, dogs, and their people. They were equal parts circus, chaos, and workout. Creating a portrait of an entire litter of rambunctious golden retrievers was total mayhem, the great danes trotted around the studio like ponies, and the corgi peed on everything.

When we began this project, we hadn't yet adopted our dog, Ducky. Watching him play with his friends makes our hearts explode. He cracks us up every day. We love to dance with him, sing to him, and give him tons of belly rubs. Even though he hogs the bed every night, he's the best.

In our interviews we asked everyone this question: "What has sharing your life with a dog given you?" It's difficult for people to articulate the depths of their feelings for their dogs. Words are limited when it comes to love. Maybe it's easiest to just say, "I have the best dog."

Ducky

GREAT PYRENEES/BORDER COLLIE MIX

A potato-size puppy grew into eighty pounds
of uncontainable love. Every dog and human he
encounters is a new best friend to be greeted
with ear nibbles and slobbery kisses. Laying
all his cards on the table, Ducky doesn't have
a poker face; but he wants to lick yours.

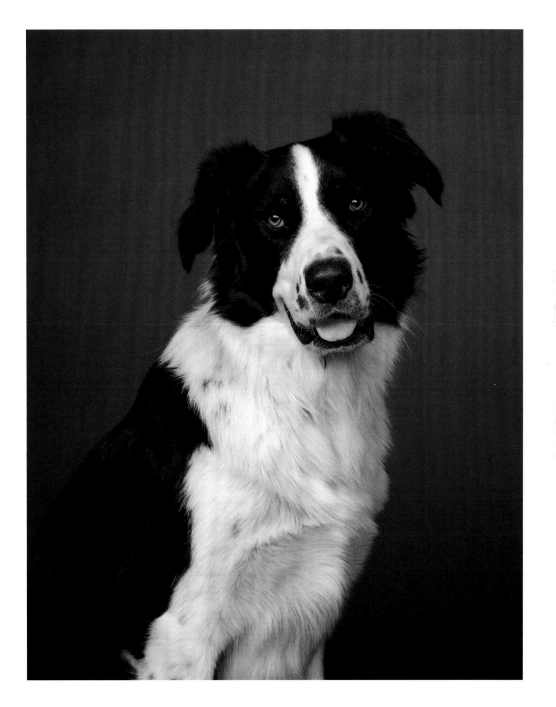

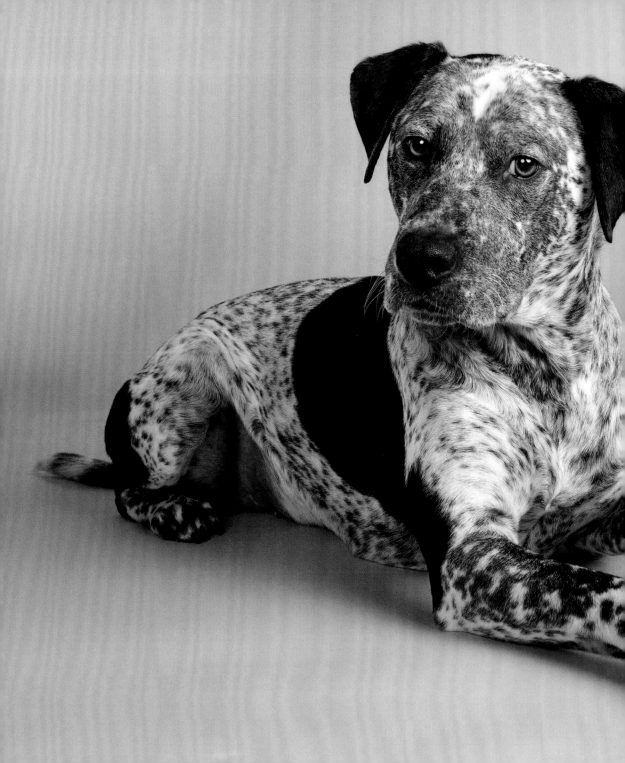

Frazier

GERMAN SHORTHAIRED POINTER/CATAHOULA LEOPARD MIX

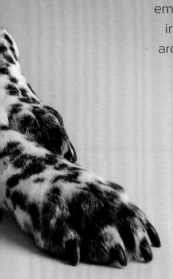

He slowly climbs into your lap and places a paw on each of your shoulders until you find yourself in a full embrace. And then, nose to nose, Frazier peers deeper into your soul than any human ever has. Everything around you disappears, and time slows down. It's just you and Frazier. Right here. Right now.

Cupid

DALMATIAN

Certified lover boy

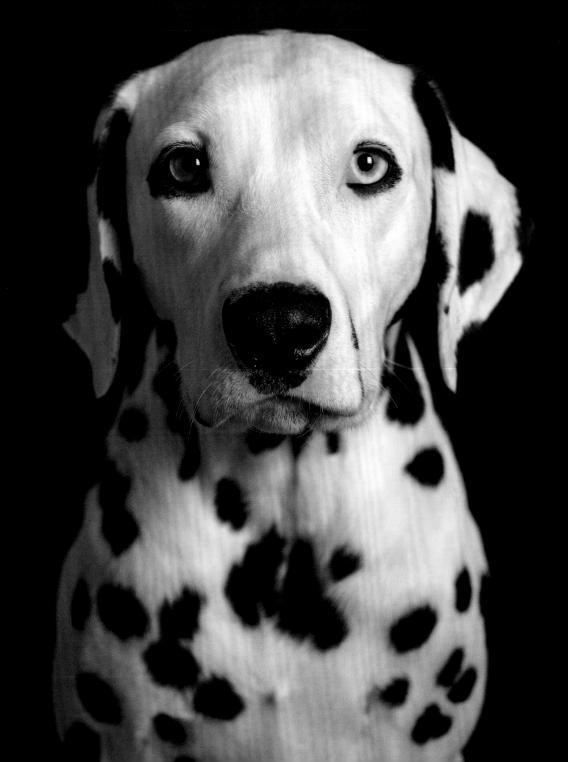

Archie

RAT TERRIER/CHIHUAHUA MIX

Coming out of his shell more and more every day.

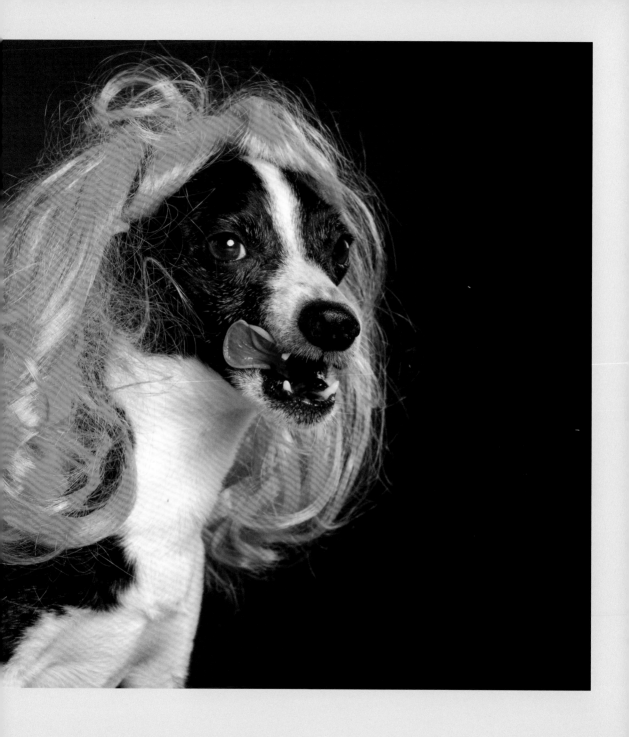

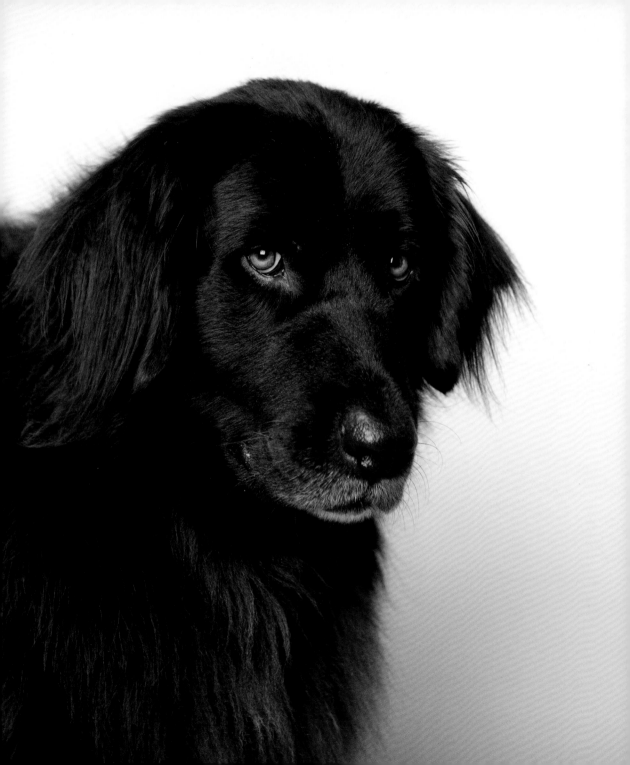

Daisy

NEWFOUNDLAND

Daisy knows the secret to letting go of the past:
run like you've never slipped on ice.

Tonks

GERMAN SHEPHERD/CATTLE DOG MIX

Tonks sat on her usual bench at the Prospect Park subway station in Brooklyn, New York, waiting patiently for the next Manhattan-bound train. She was headed to work at the dog-friendly office where she often went with her person, Meghan. The problem was that Tonks wasn't with Meghan. She was alone.

Later, multiple eyewitnesses would help piece together a timeline of the events that transpired. Prior to bounding down the stairs and ducking the turnstile, Tonks had run down Flatbush Avenue dodging people, cars, cabs, and buses. She'd done a lap through Prospect Park and pooped in front of a police officer at a busy intersection.

Which brings us back to that morning, when a new dog walker showed up alone at their apartment. A smart but nervous dog, Tonks was frightened by the new person, and as soon as the dog walker got her outside, she bolted.

Luckily, a concerned couple spotted the dog in the subway station without a human and knew something was wrong. They approached the runaway pup and called the number on her tag. Meghan was horrified to hear that Tonks was not safe at home, and frantically dashed back to Brooklyn.

Reunited with her best girl, Meghan barely had time to catch her breath before she learned a photo of Tonks alone on the subway platform had gone viral. Now, a few years later, Meghan can look back at the photo with a smile. "I think it's time to get it framed."

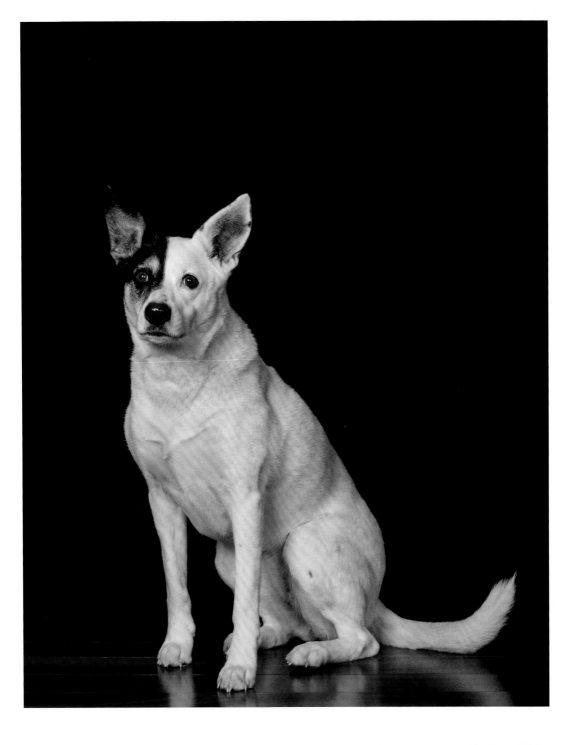

Wanda

BOXER/AMERICAN PIT BULL TERRIER/DOBERMAN PINSCHER MIX

If you knocked on the door of her New York City
apartment, Wanda would crack it open just a
sliver, politely say, "No thank you," then close
it surprisingly hard in your face. She would then
walk back upstairs, climb into her favorite chair,
and resume relaxing . . . thank you very much.

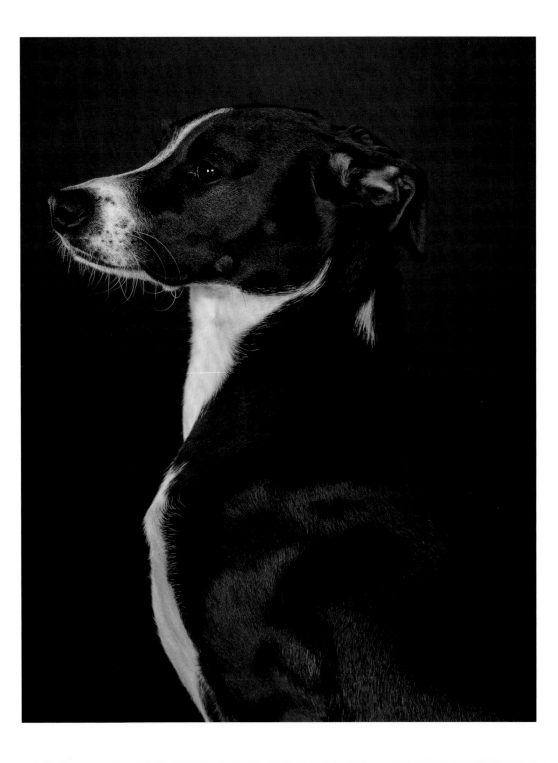

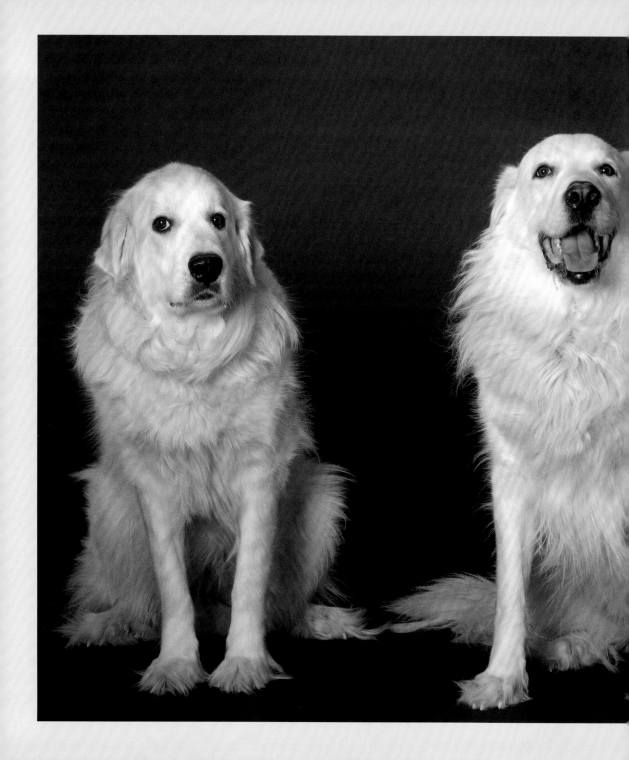

Meadow
& Willow

GREAT PYRENEES

Protecting the sheep at Prado de Lana farm
is their full-time job. But these two can't
resist a night out on the town, even if it
means being sprayed by skunks, quilled by
porcupines, or picked up by the police.

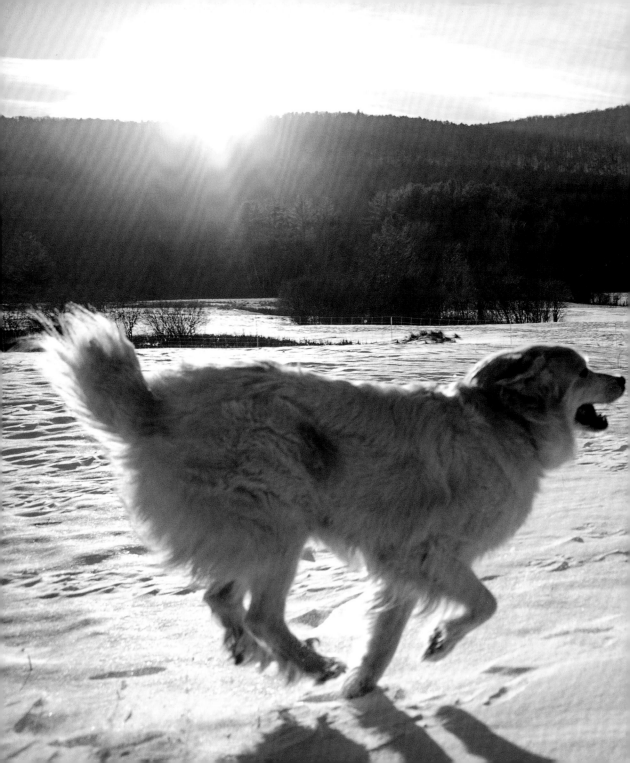

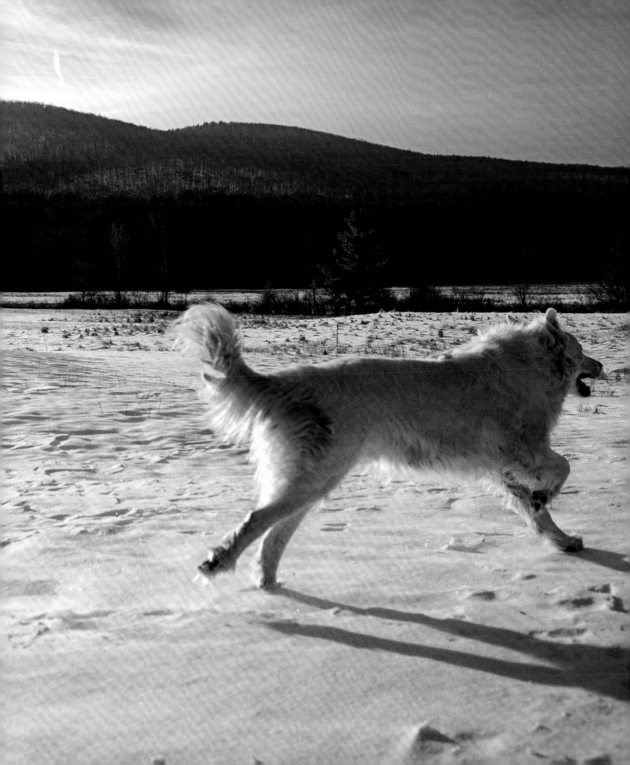

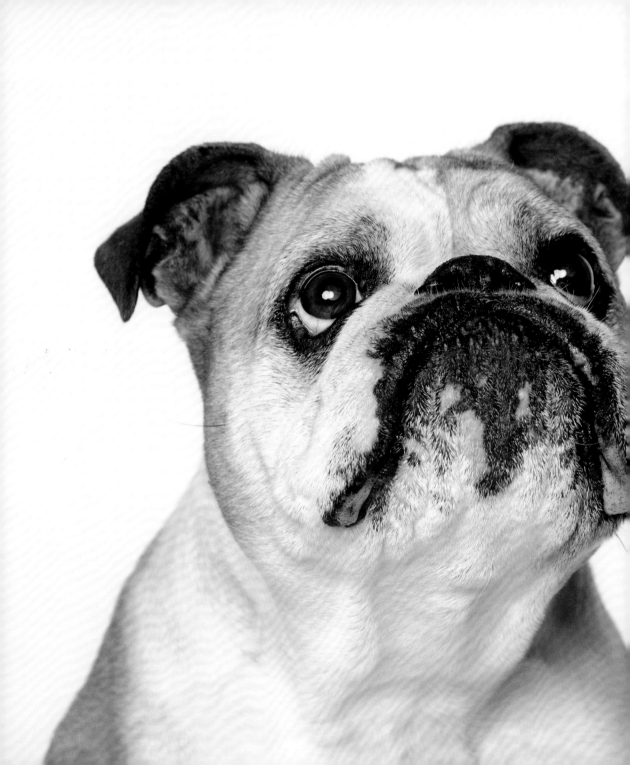

Frank

BULLDOG MIX

Frank's favorite thing is his trailer tire. On his birthday,
the tire is wrapped and presented to him. After destroying
the wrapping paper, Frank thrashes, chews, and
drags the tire around in a crazed state of rapture until
it is taken away and hidden. At Christmas, the same
tire is wrapped and re-gifted. Every year at every holiday,
Frank is given the same tire, and every single time
it's the best gift he's ever gotten.

One year Frank was gifted a new dog friend named Fred.

Frankly, Frank prefers the tire.

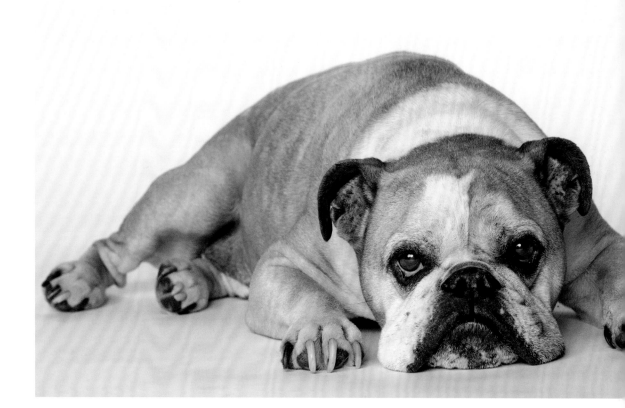

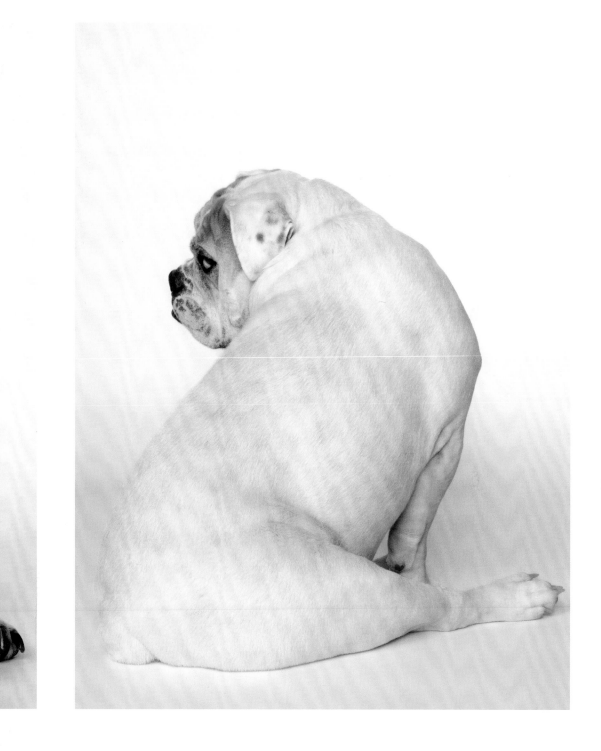

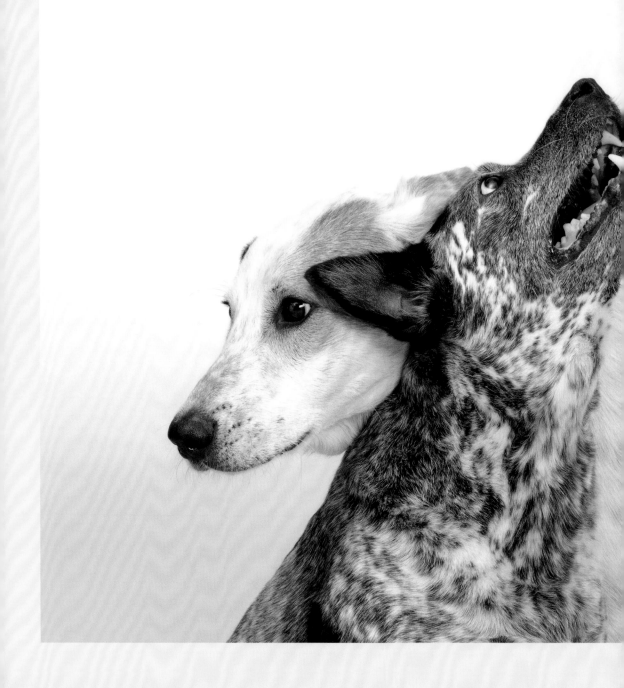

Moby & Doc

BLUE HEELER & GREAT PYRENEES MIX

Sometimes you get a dog for your dog, and it turns out that dog really needed a friend, too.

June

GREAT PYRENEES MIX

This comfort queen is for the sheets, not the streets:
couch, bed, couch, bed, repeat.

If you take June out for a walk, be ready to carry
her home.

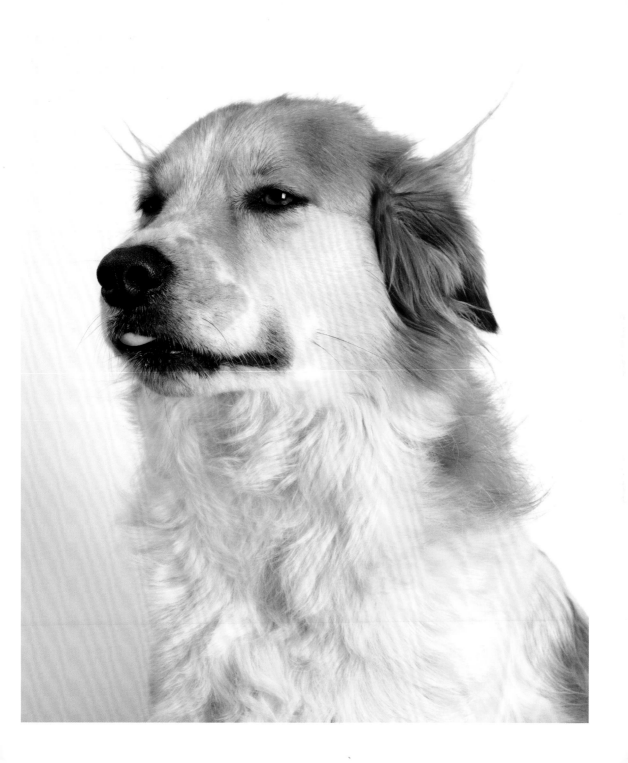

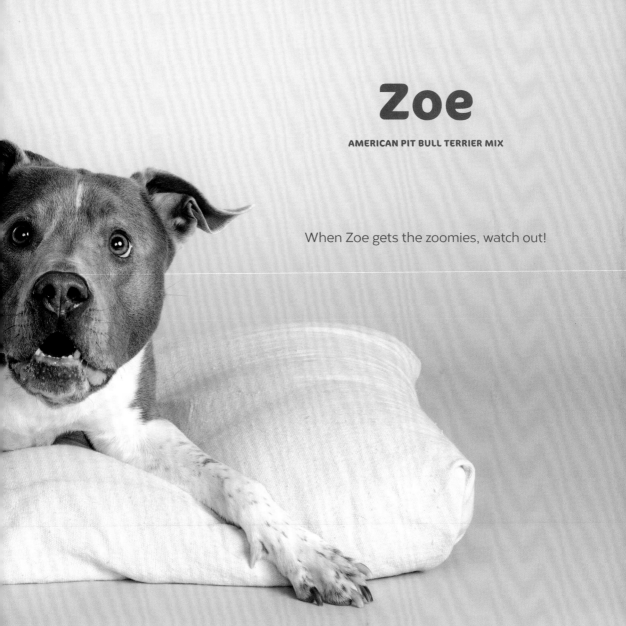

Zoe

AMERICAN PIT BULL TERRIER MIX

When Zoe gets the zoomies, watch out!

Mamba

BORDER COLLIE

A champion dock diver, Mamba flies through the air like a superhero before splashing down in the pool.

Cannonball!

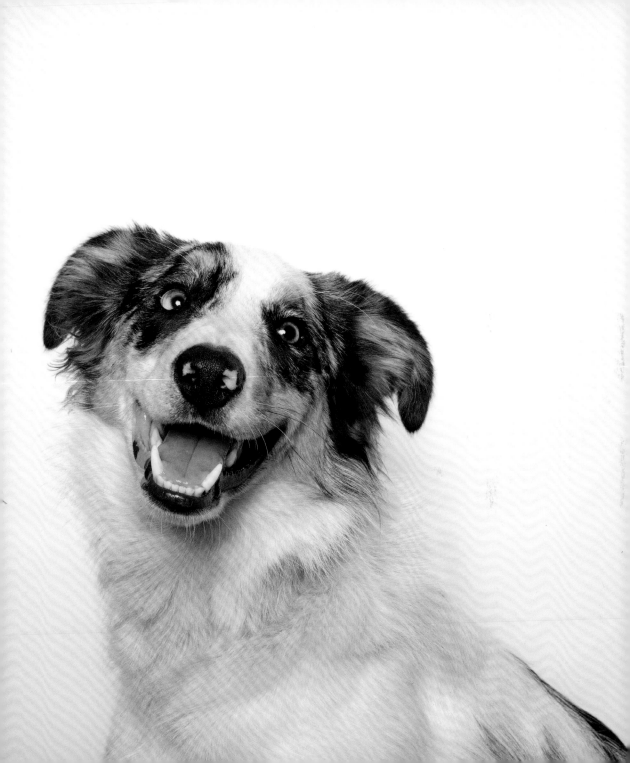

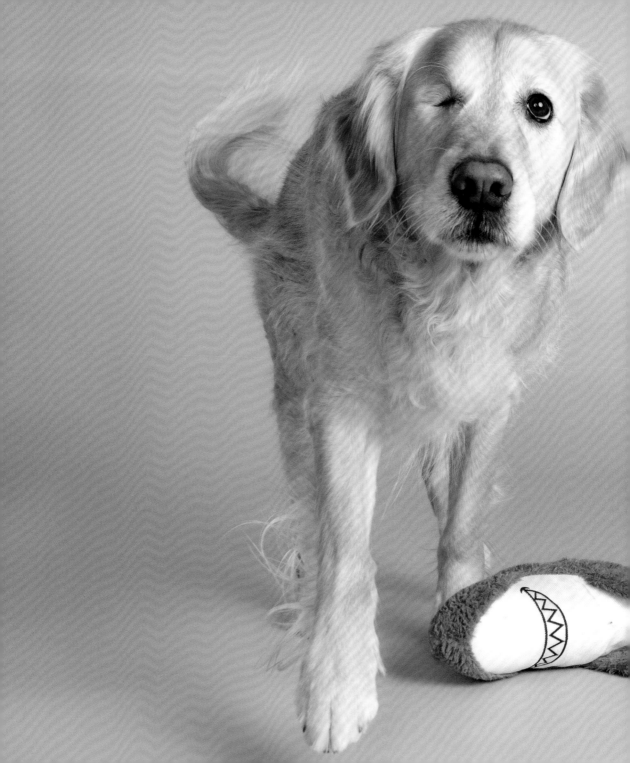

Captain One-Eyed Willie

GOLDEN RETRIEVER

Greatest achievement: won a whipped cream–eating contest at the county fair.

Reeses

NOVIA SCOTIA DUCK TOLLING RETRIEVER

The smallest breed of retriever, with the longest name.

What he lacks in size, he makes up for in personality.

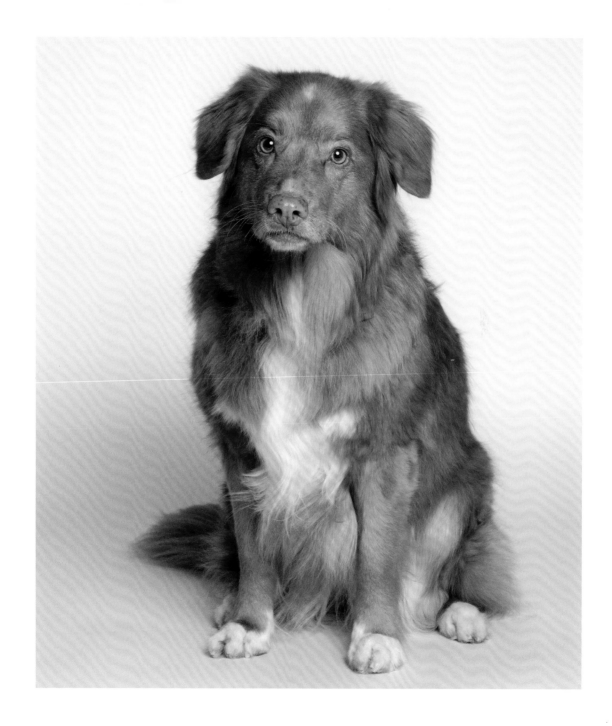

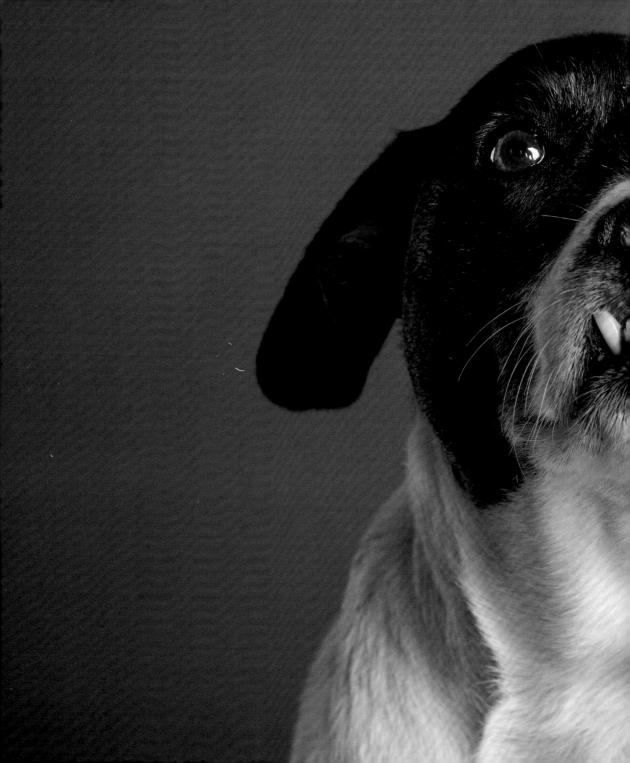

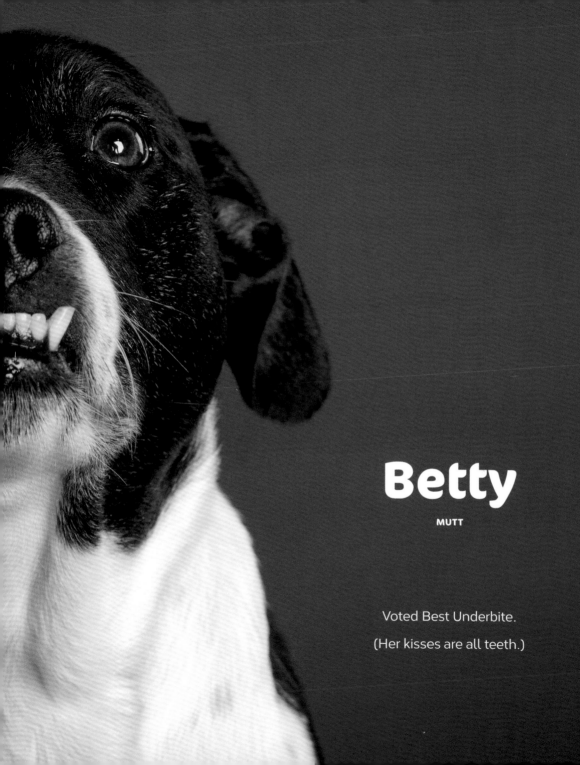

Betty

MUTT

Voted Best Underbite.

(Her kisses are all teeth.)

Zu

AMERICAN PIT BULL TERRIER MIX

Some folks build their lives around their dog. Zu was dog reactive, and his busy neighborhood stressed him out. So what did the best dog parents do? They bought him a homestead, of course! This beautiful brindle blockhead now has acres of land to play with the goats, the chickens, and his B-A-L-L.

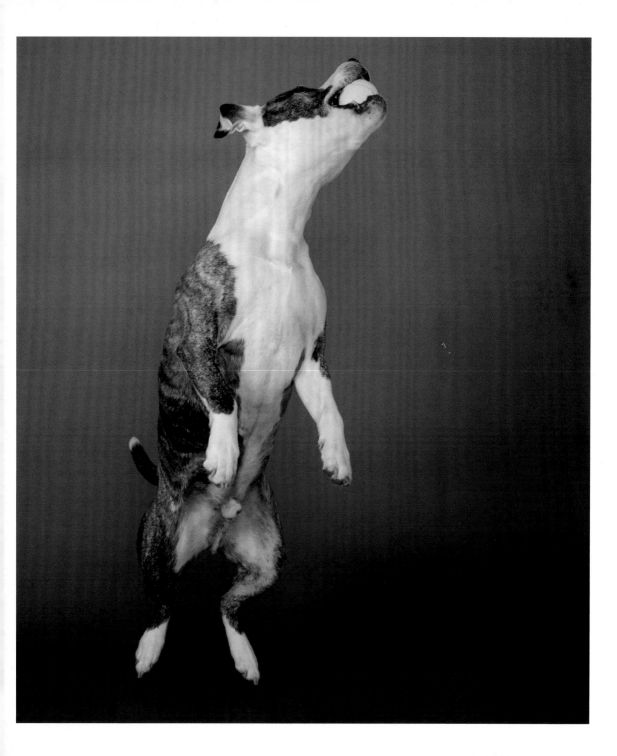

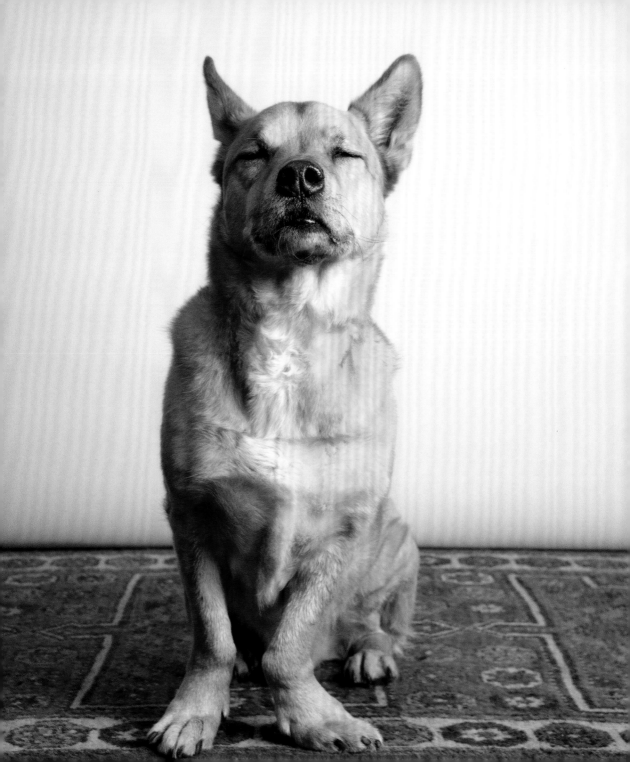

Rufus

MUTT

When Brie brought him along on her first date with Jeff, Rufus stole and wolfed down a couple pounds of artisanal salami. Strangely, all-night-doggie-diarrhea bonded the two humans, who are now in a serious relationship. Rufus still dreams about that salami.

Teddy & Raffles

TERRIER MIXES

Inseparable brothers with low-tide breath.

Raffles is on Prozac.

Teddy eats his emotions.

Raffles barks at everyone.

Teddy is needy.

But nestled together in their basket, they're perfectly imperfect angels.

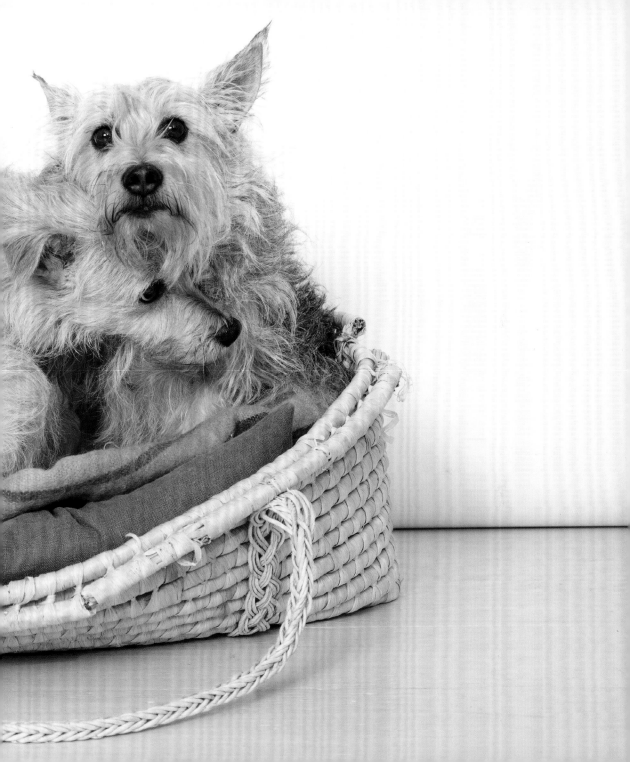

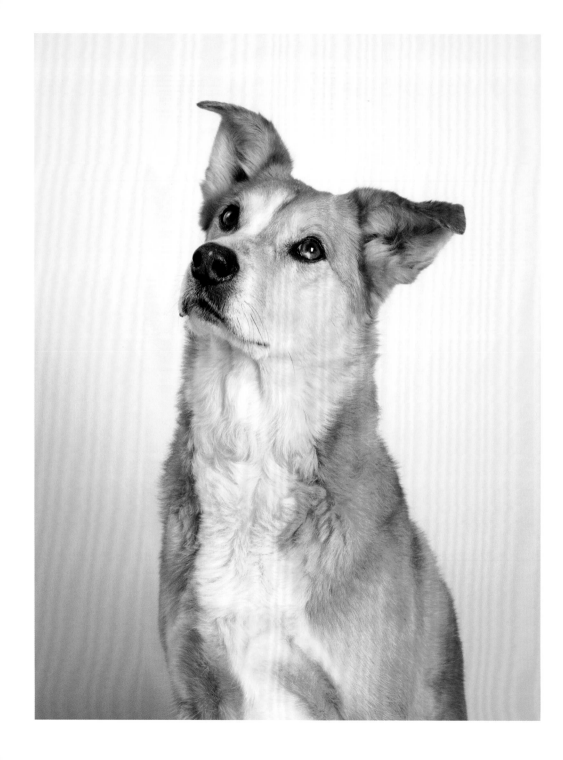

Waylon

CATTLE DOG MIX

Named after outlaw country singer Waylon Jennings, the neurotic cattle dog grew up to be more like Woody Allen, following his person from room to room with a perpetually concerned expression. *What's that sound? Did you hear that sound?*

Josie

ENGLISH SHEPHERD

Fourth of July fireworks sent her bolting.

A holiday party turned into a search party.

The next morning, as lost dog flyers were being made, Josie showed up at the door, wet, shaking, and covered in mud.

Fireworks aren't fun for everyone.

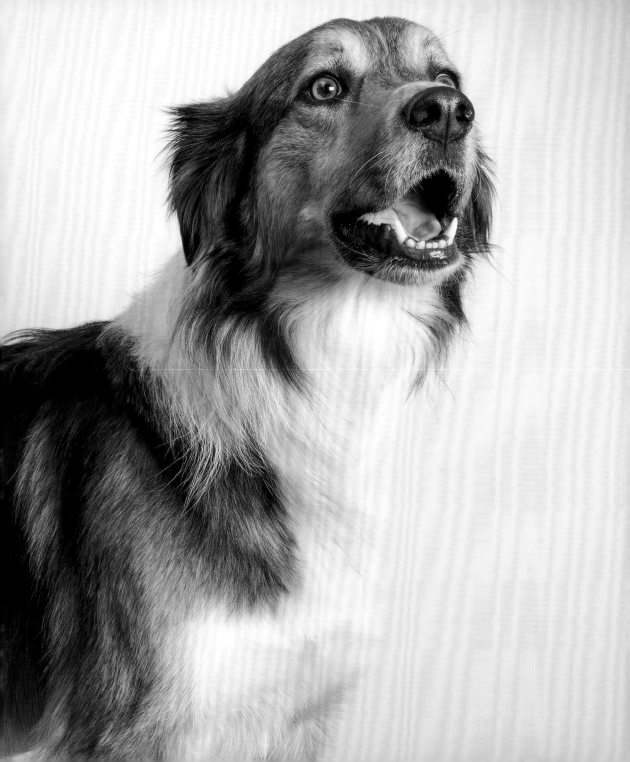

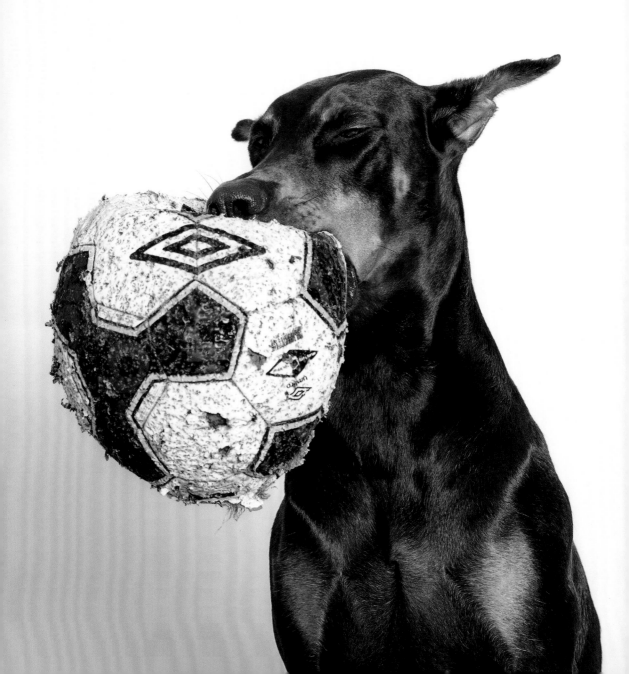

Venus

DOBERMAN PINSCHER

Medical alert dog and soccer diehard.

On and off the field, she works and plays like a girl.

Friday

WEST HIGHLAND WHITE TERRIER

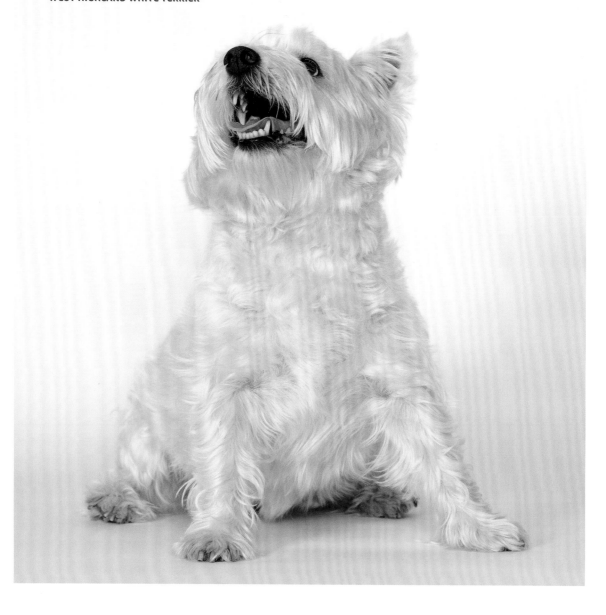

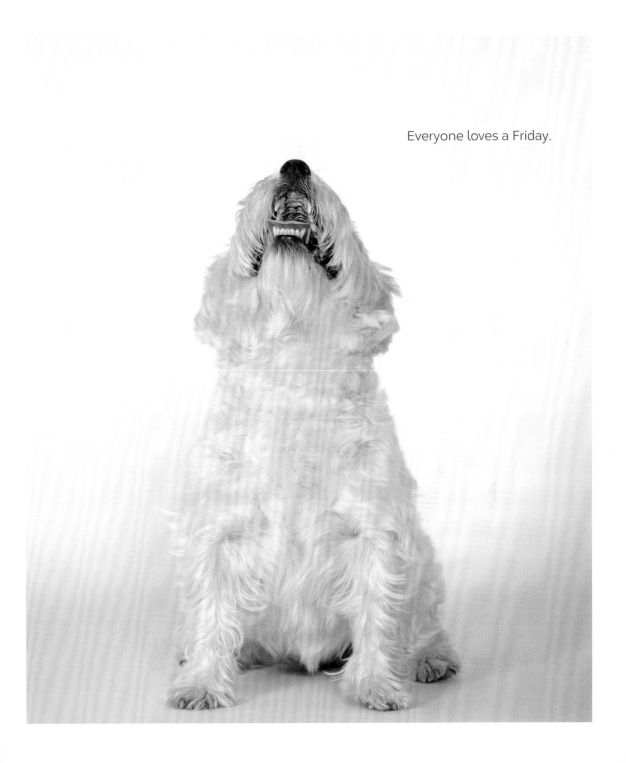

Everyone loves a Friday.

Iggy Pup

CATAHOULA LEOPARD MIX

She's got a lust for life.

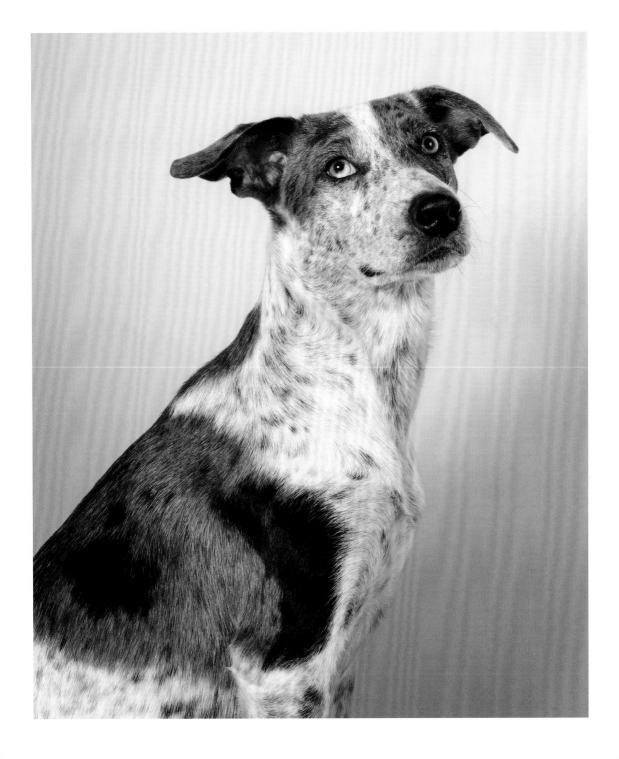

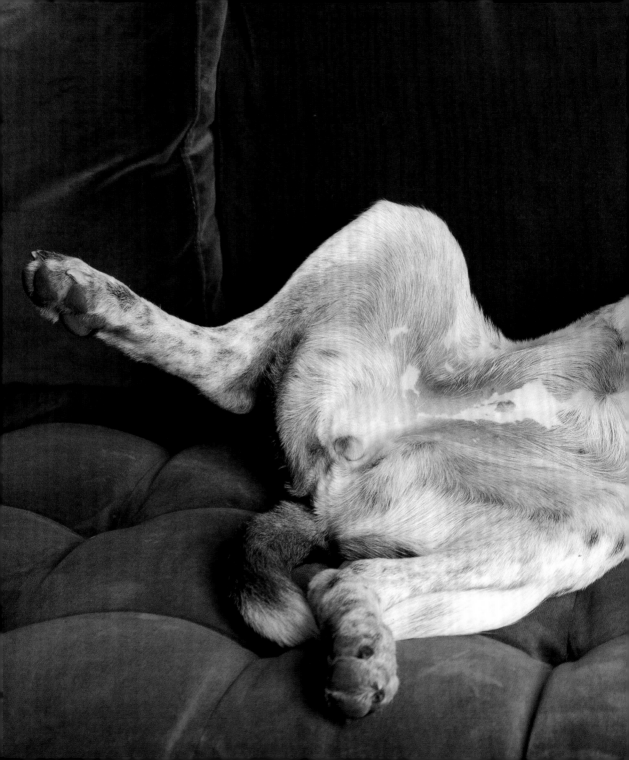

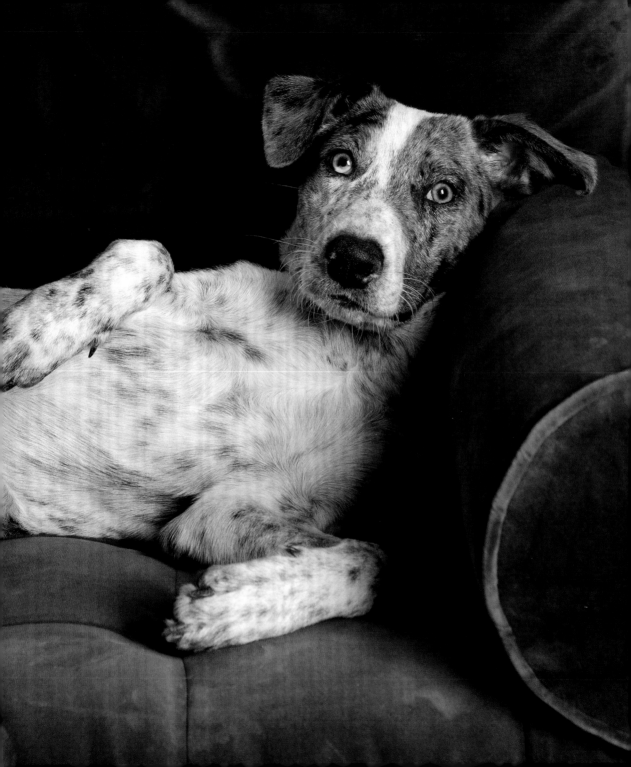

Rosie

ITALIAN GREYHOUND

Tiny Dancer

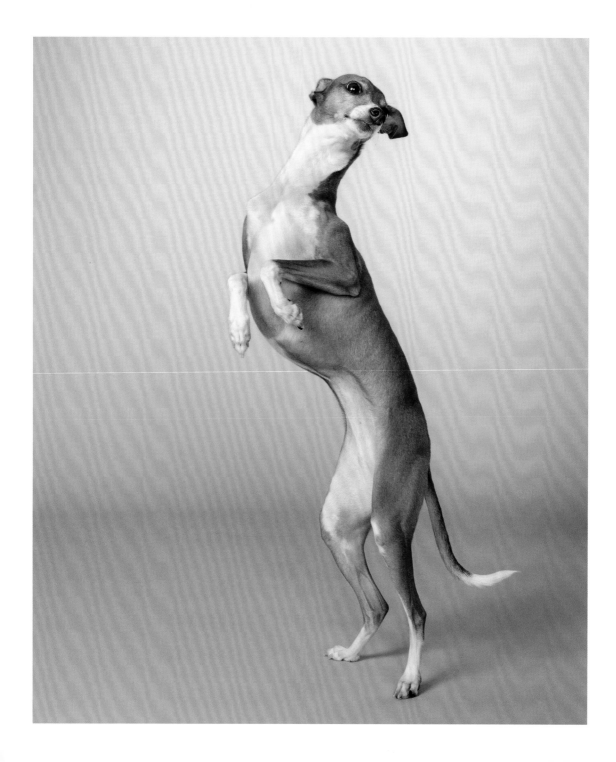

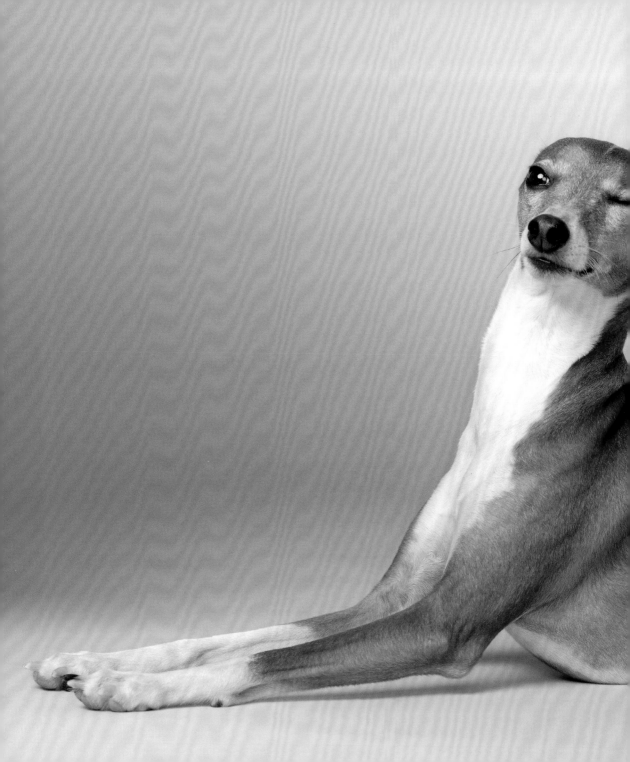

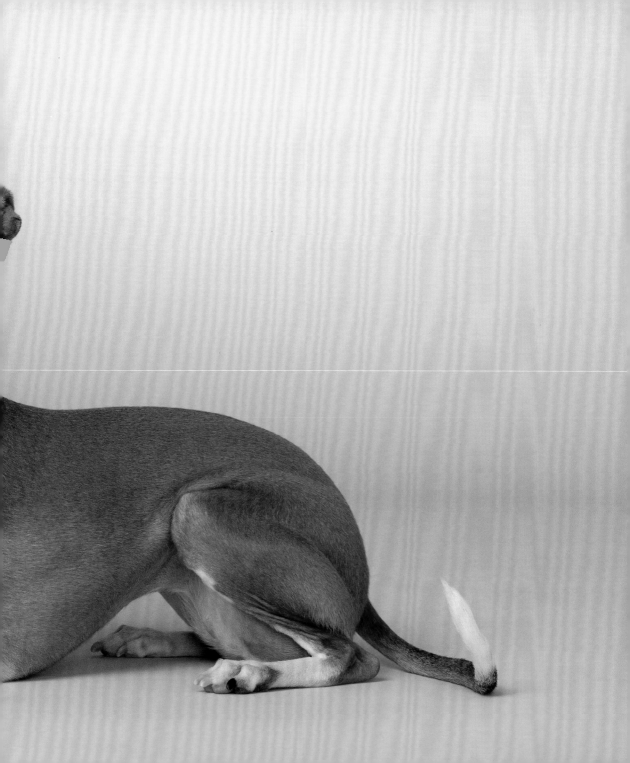

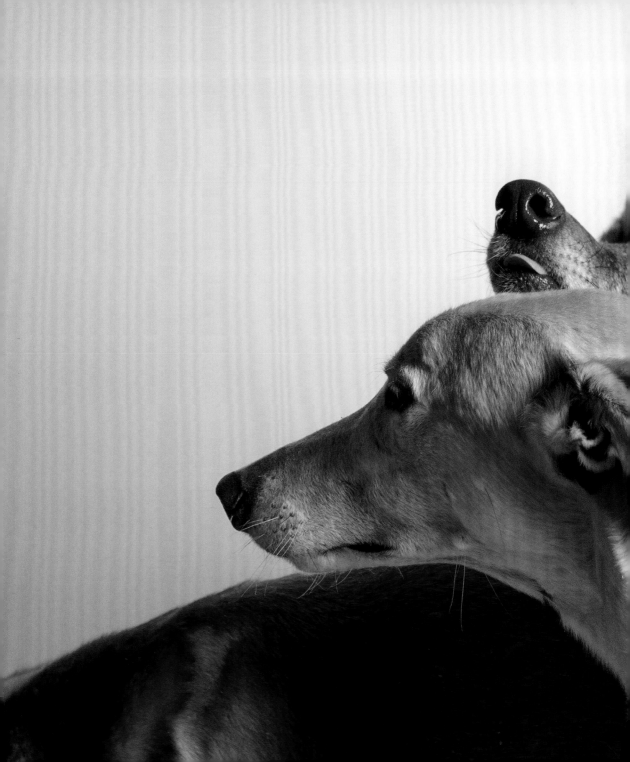

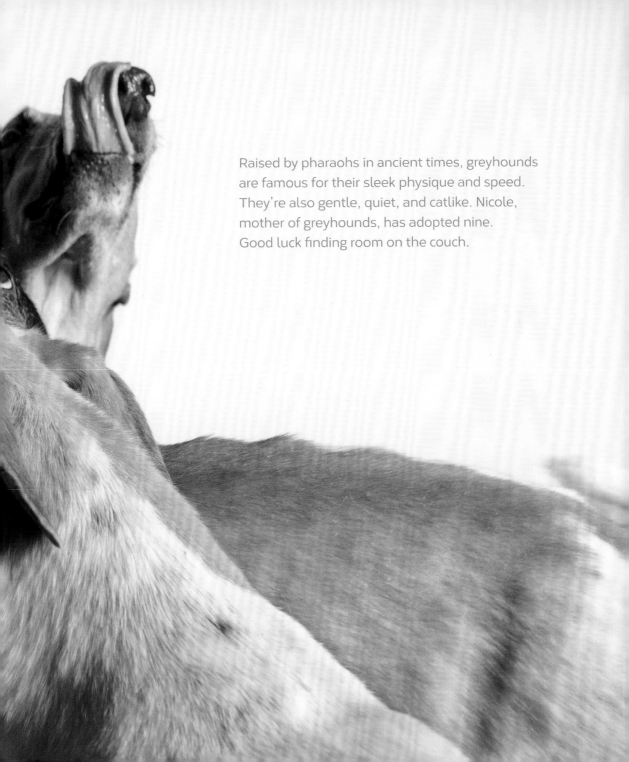

Raised by pharaohs in ancient times, greyhounds
are famous for their sleek physique and speed.
They're also gentle, quiet, and catlike. Nicole,
mother of greyhounds, has adopted nine.
Good luck finding room on the couch.

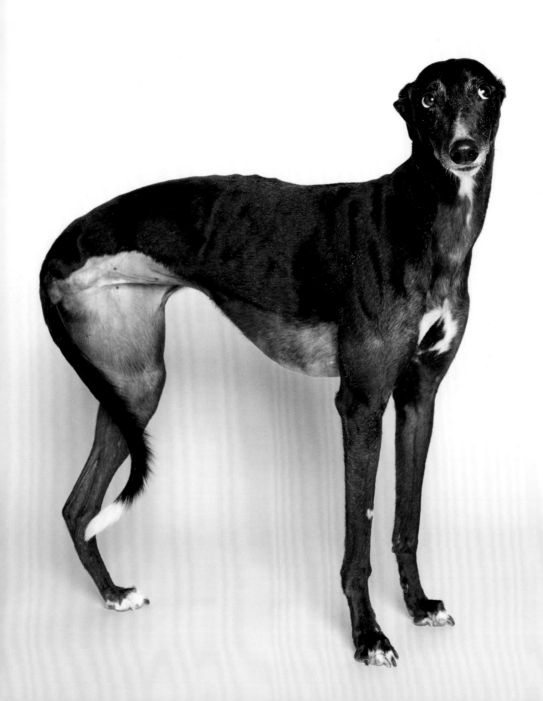

Ellie Mae

GREYHOUND

Just try to outrun this tripod.

She'll leave you in the dust.

Squid

POMERANIAN

Rachel and Michael walked into their bedroom and were transfixed by the mysterious creature lying next to their new pomeranian pup, Squid.

Less than a month earlier, they'd adopted the frightened puppy mill rescue. Now they realized she'd been carrying a little secret. The pom had just delivered a surprise puppy on their bed. Throughout the night she delivered two more.

By morning the tired couple had a house full of pomeranians, and a whole lot of laundry to do.

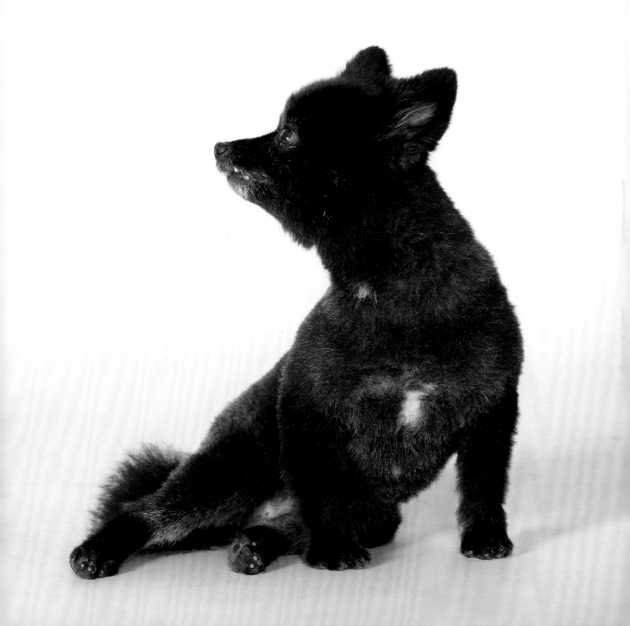

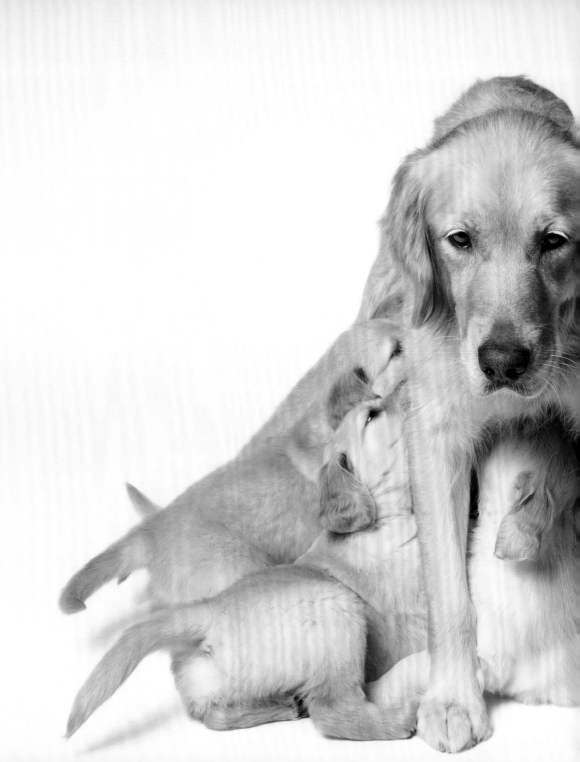

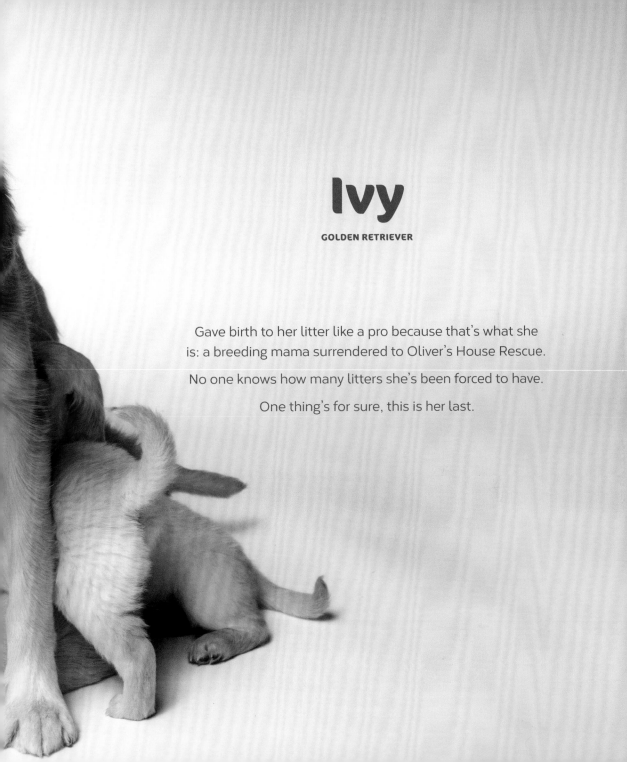

Ivy

GOLDEN RETRIEVER

Gave birth to her litter like a pro because that's what she is: a breeding mama surrendered to Oliver's House Rescue.

No one knows how many litters she's been forced to have.

One thing's for sure, this is her last.

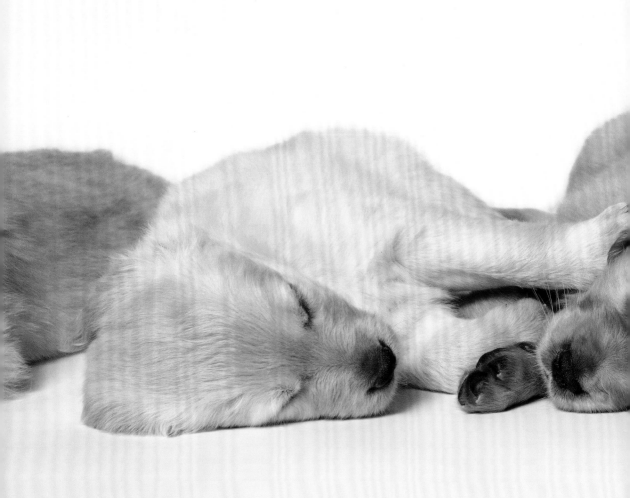

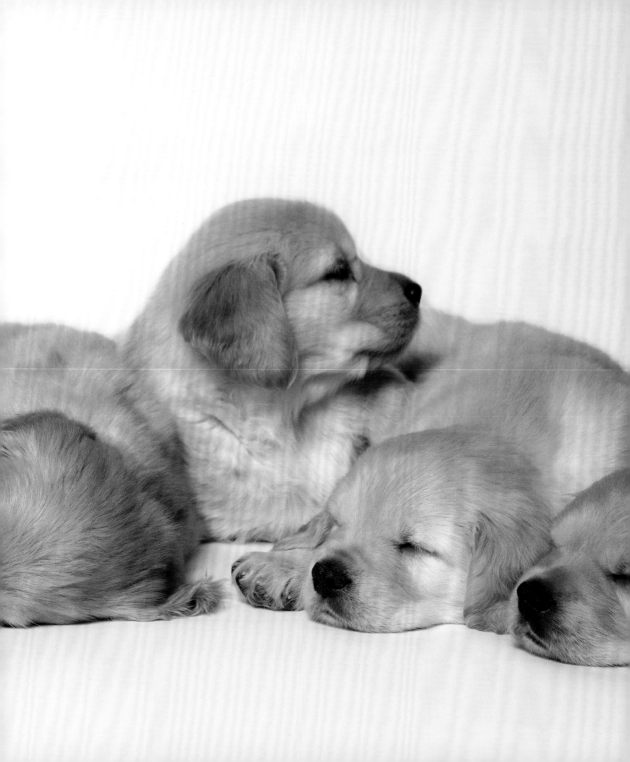

Wilson

TERRIER MIX

He smiles with his eyes, and his tail wags up and
down, never ever side to side.

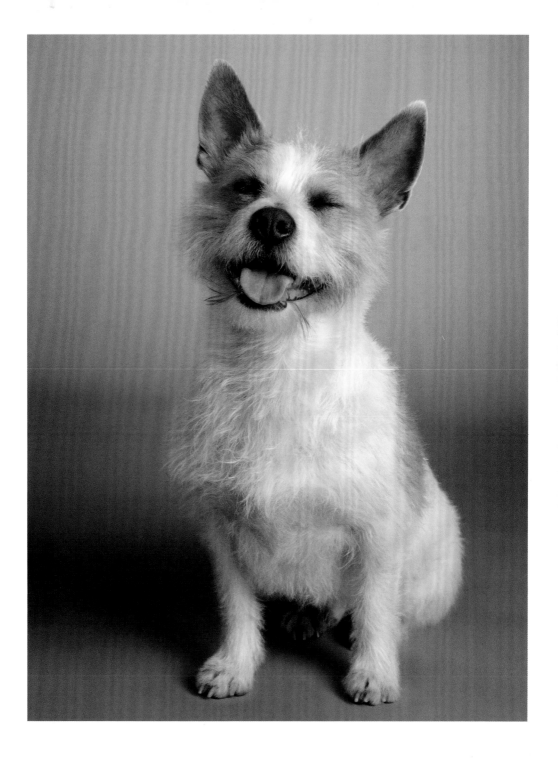

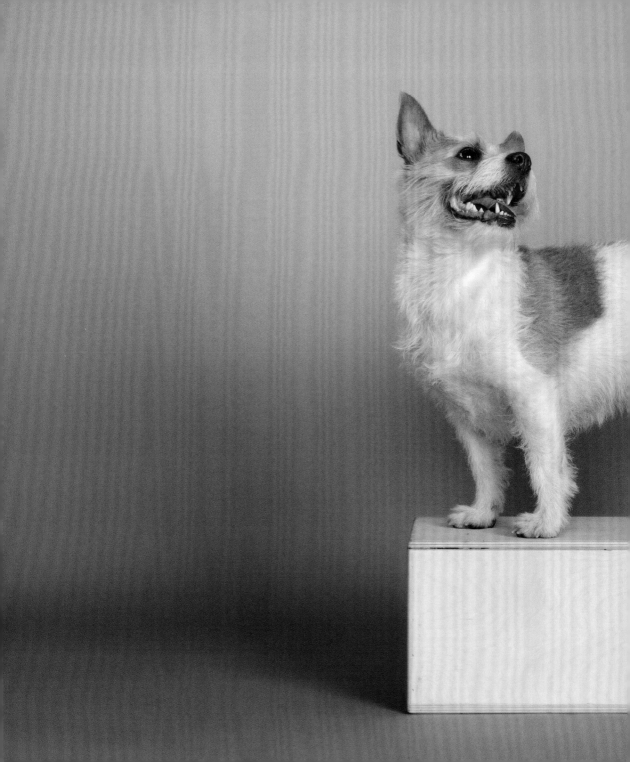

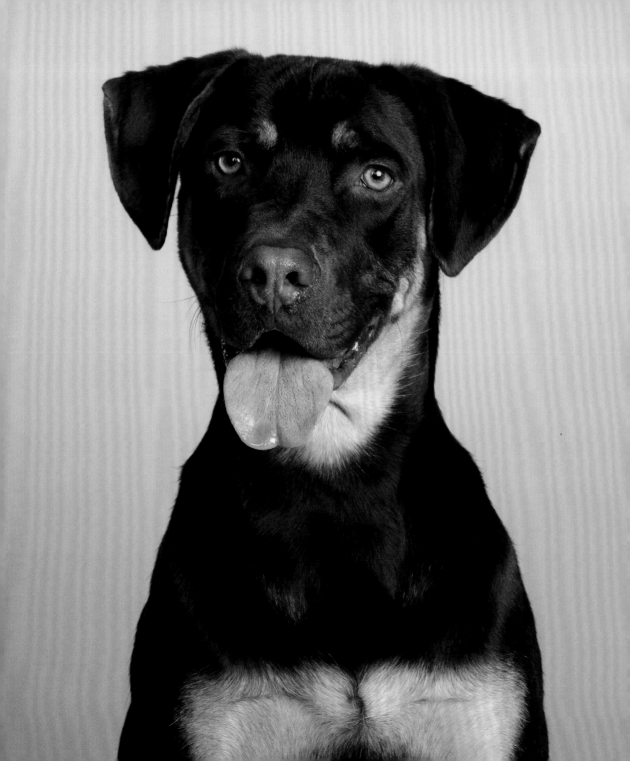

Astro Jetson

LABRADOR/CATAHOULA LEOPARD/COONHOUND MIX

He makes bad days better and good days outta this world.

Percy

SCOTTISH DEERHOUND

Once bred to stalk the wild red deer of Scotland . . .

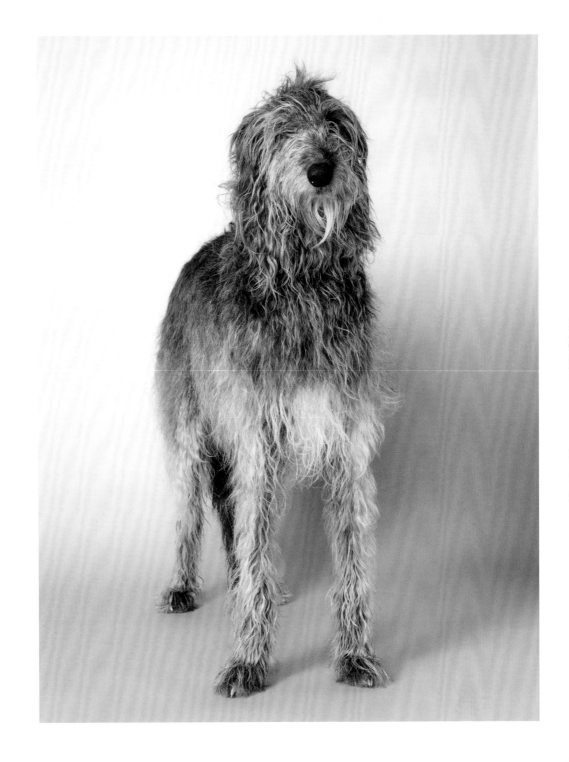

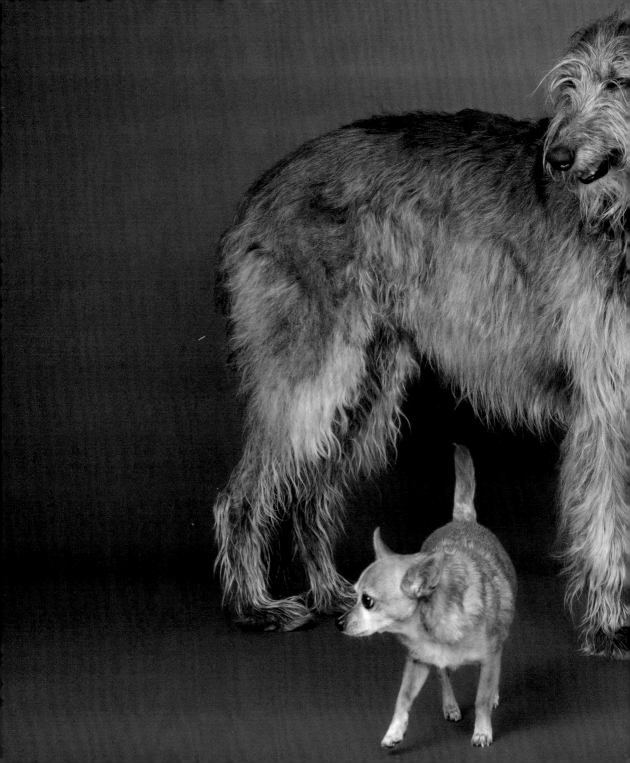

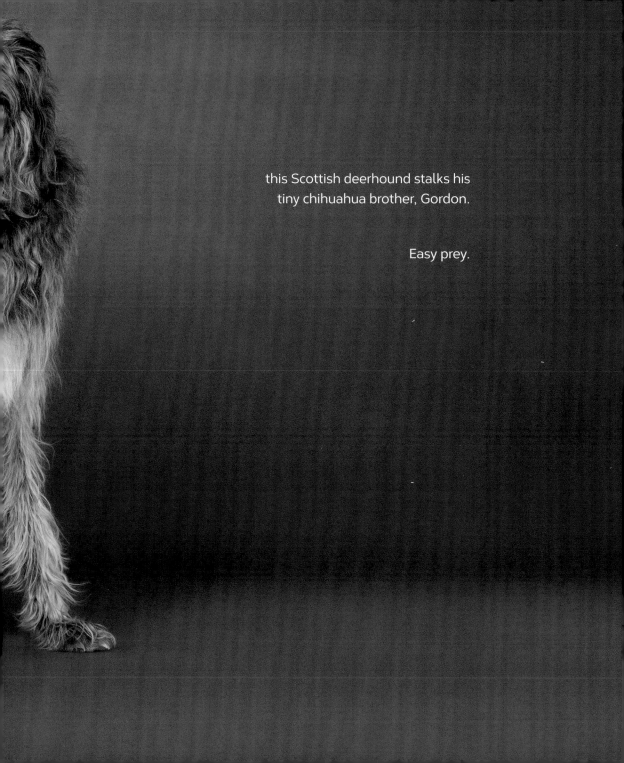

this Scottish deerhound stalks his
tiny chihuahua brother, Gordon.

Easy prey.

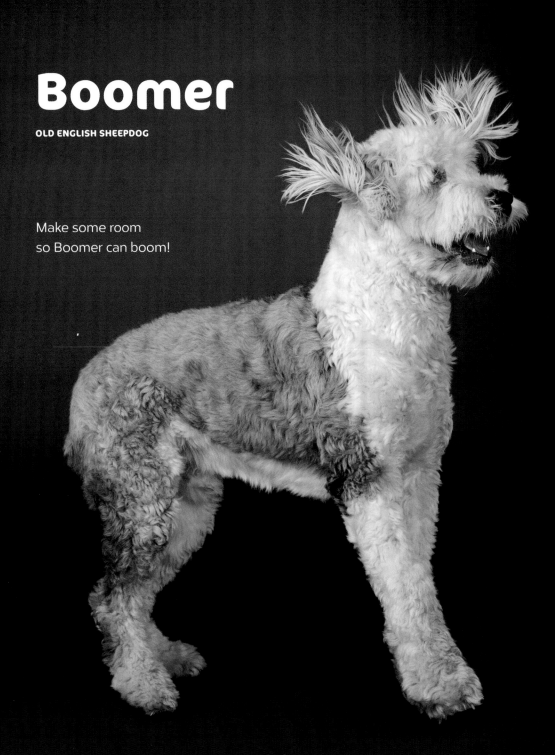

Boomer

OLD ENGLISH SHEEPDOG

Make some room
so Boomer can boom!

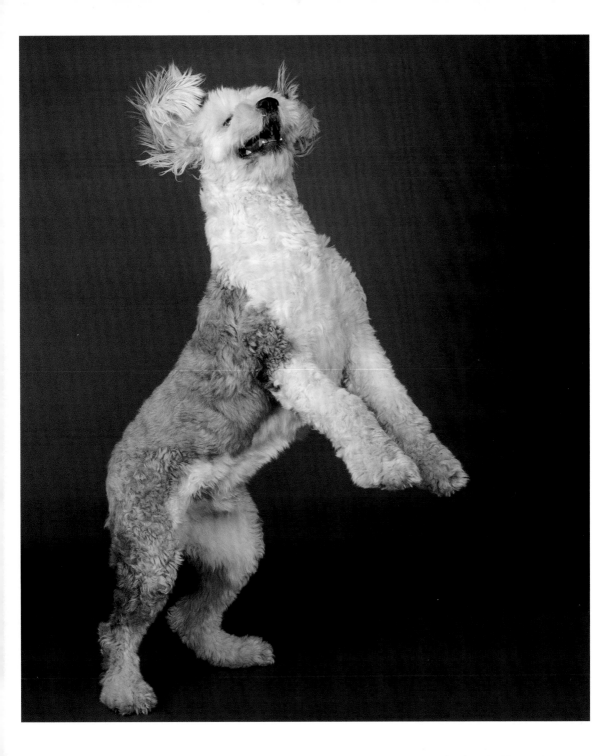

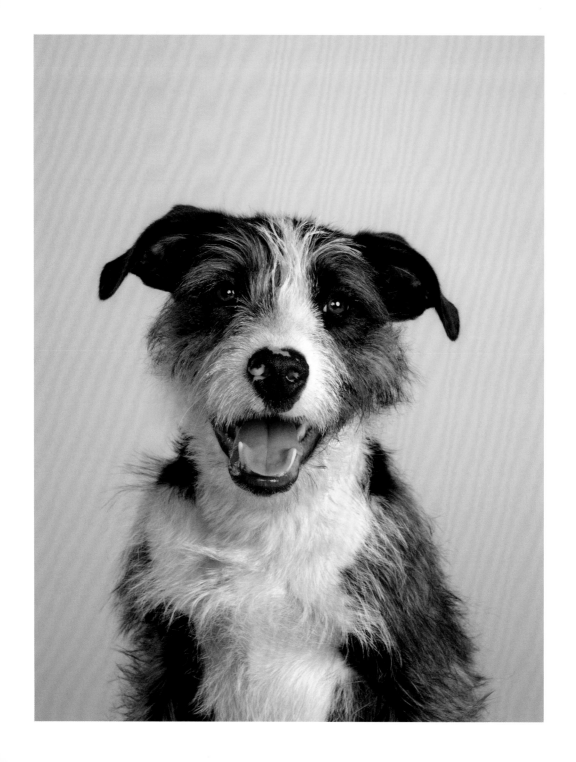

Scrappy

MUTT

He's like living with a cartoon.

Jonathan XIV

SIBERIAN HUSKY

Beloved University of Connecticut mascot.

Greeted by thunderous applause and shouts of "Let's go, Huskies!," Jonathan has the power to fire up an entire stadium of crazed UConn fans.

Cared for by the Alpha Phi Omega service fraternity, he strolls through campus like a rock star, stopping for scritches and selfies before being whisked away to a top-secret location.

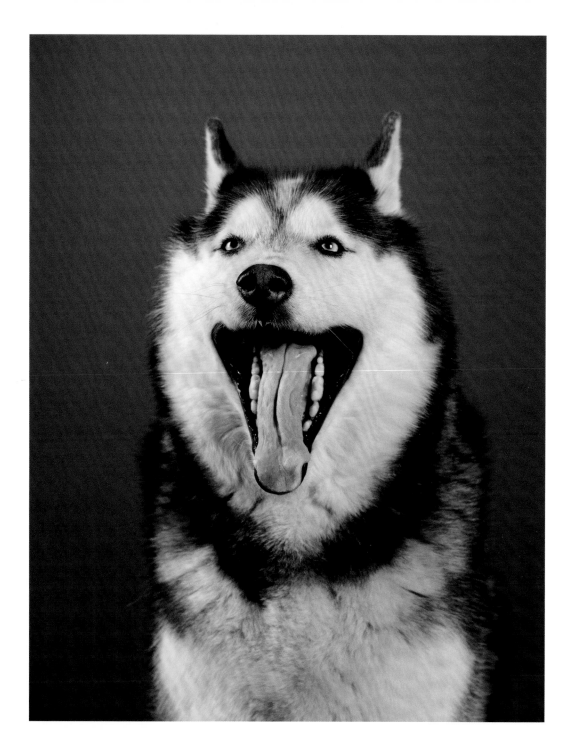

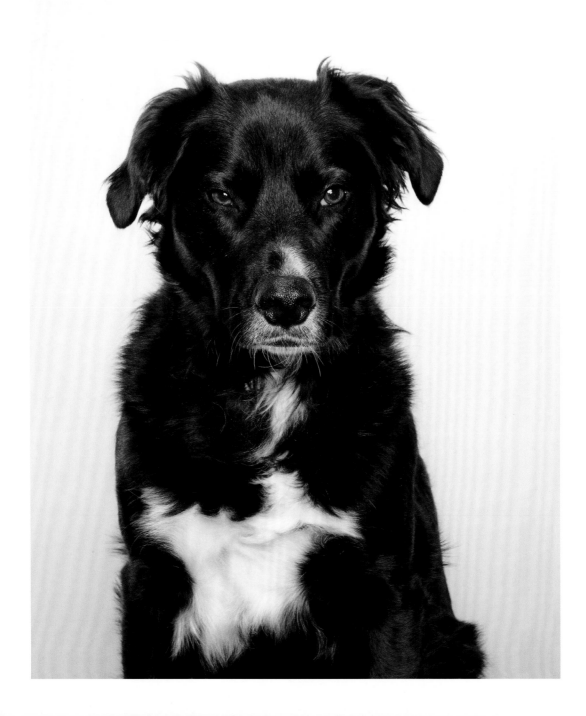

Yoshi

ANGUILLA POTCAKE

A sick stray turned savior.

This canine parvovirus survivor now donates antibody-rich blood to save lives.

Stanley

BORDER COLLIE/GREAT PYRENEES MIX

Thanks to a blood transfusion from Yoshi, he survived parvovirus and grew into a charming Southern gentleman.

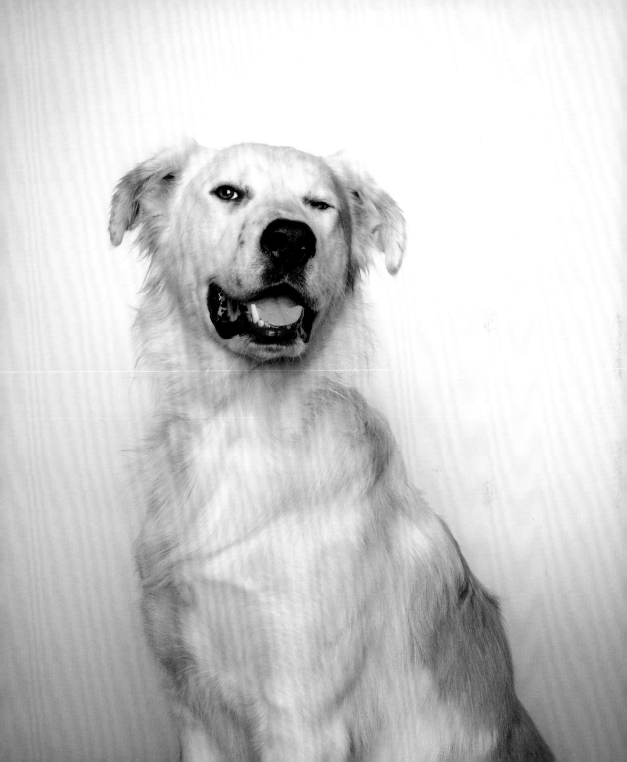

Maurice & Bernice

PUG & GREAT DANE

One of these dogs has a Napoleon complex.

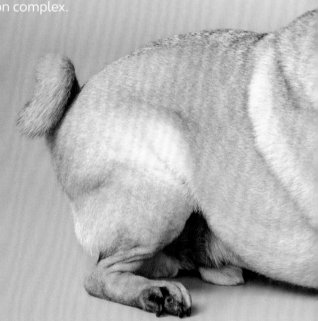

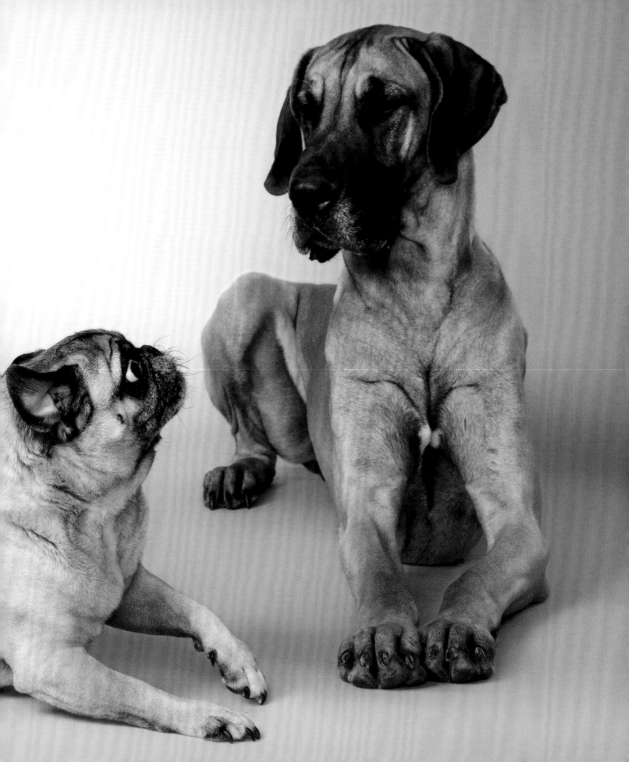

Tetley

SCHNAUZER MIX

A scruffy muffin

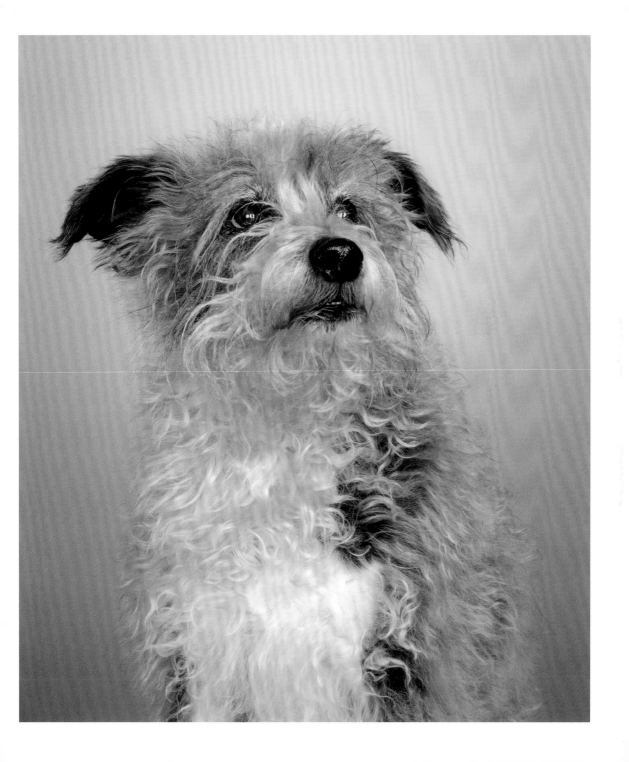

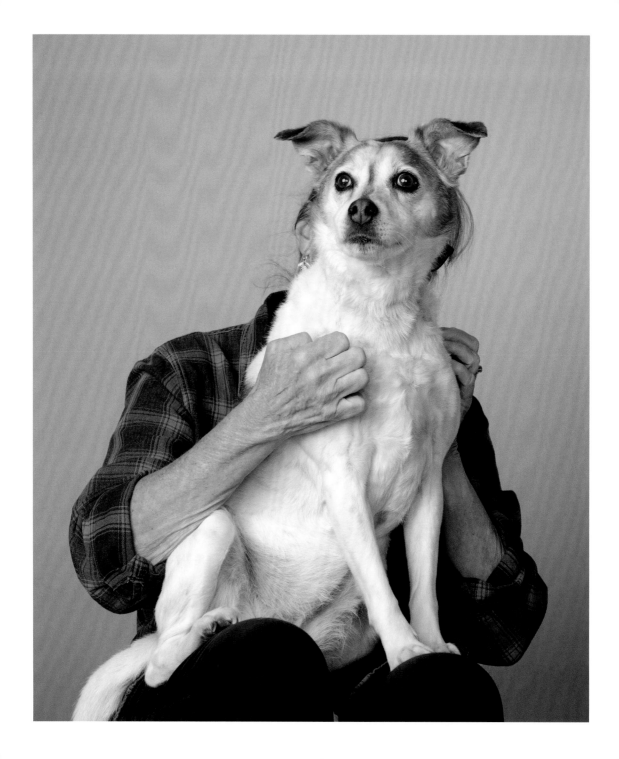

Maggie

JACK RUSSELL TERRIER MIX

Maggie loves riding in Betsy's kayak to deliver
homemade cookies to hungry lobstermen.

Chips ahoy!

Tasi

GUAM BOONIE DOG

Lauren hadn't seen her favorite local Guam street dog for a while. The savvy pup was usually begging for food at the beach bar, but Tasi was nowhere to be found. Lauren heard that the dog was locked up on a rooftop, with little to eat or drink.

She was determined to save Tasi.

It took an entire month, but on a beautiful island day, Tasi was taken off the roof and given to Lauren.

It's unclear whether dogs can experience gratitude, but from that day on, Tasi's been stuck to Lauren's side like glue. So fierce is their connection that Lauren considers Tasi more like a sister than a pet.

Tasi inspired Lauren to keep fighting for the welfare of other dogs on the island. She started the Boonie Flight Project rescue and led an initiative that established the first large-scale spay and neutering program on Guam.

All thanks to Tasi.

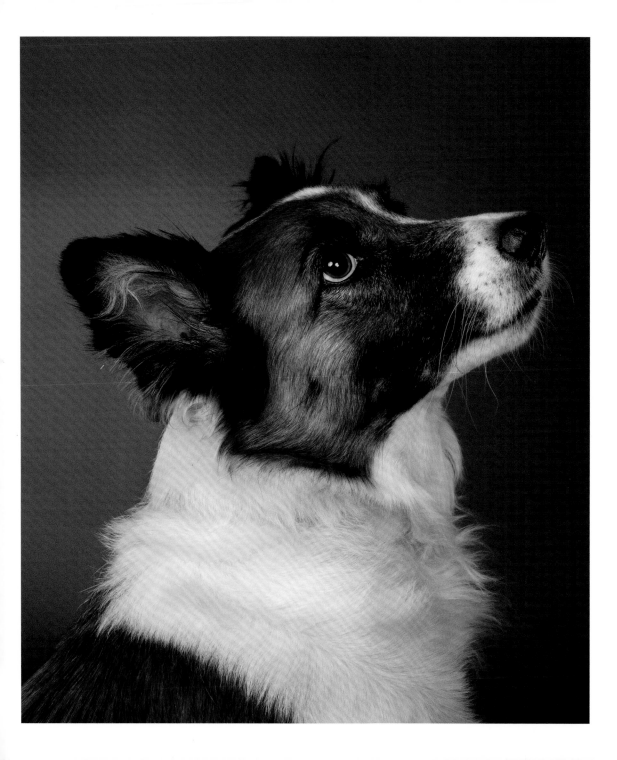

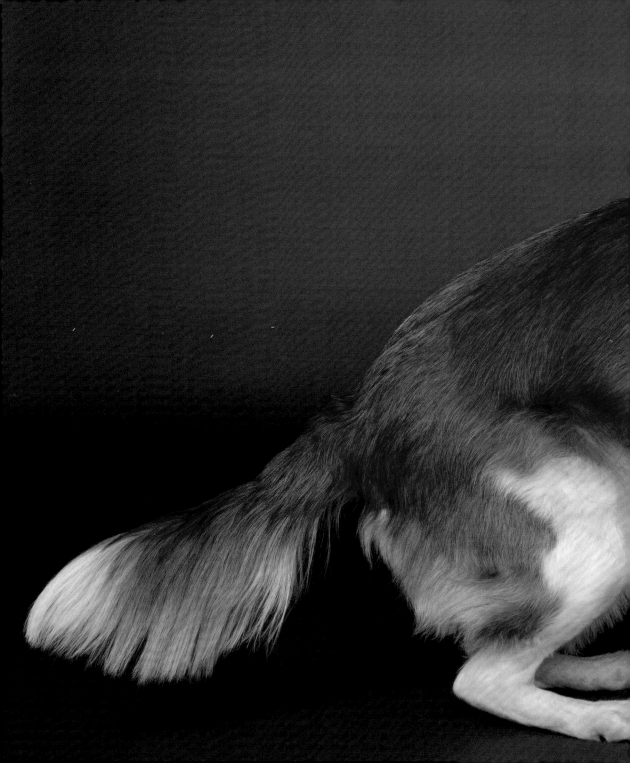

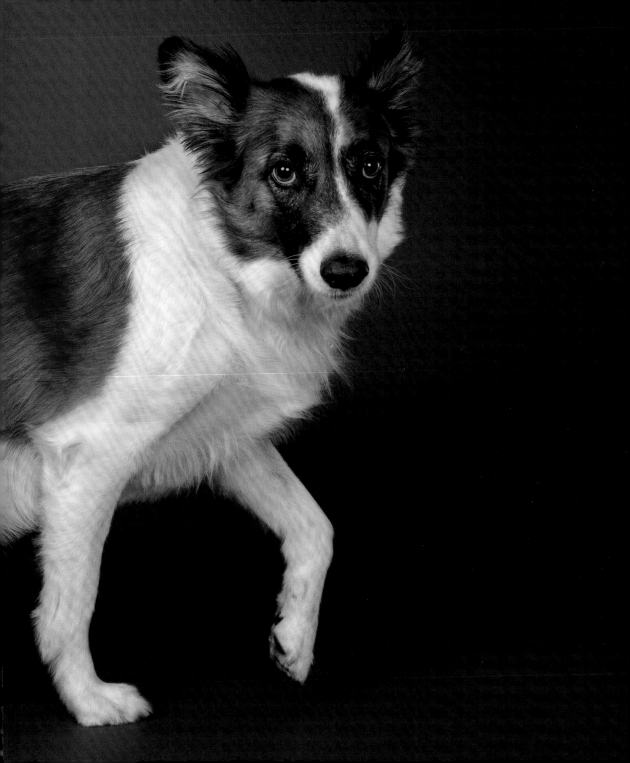

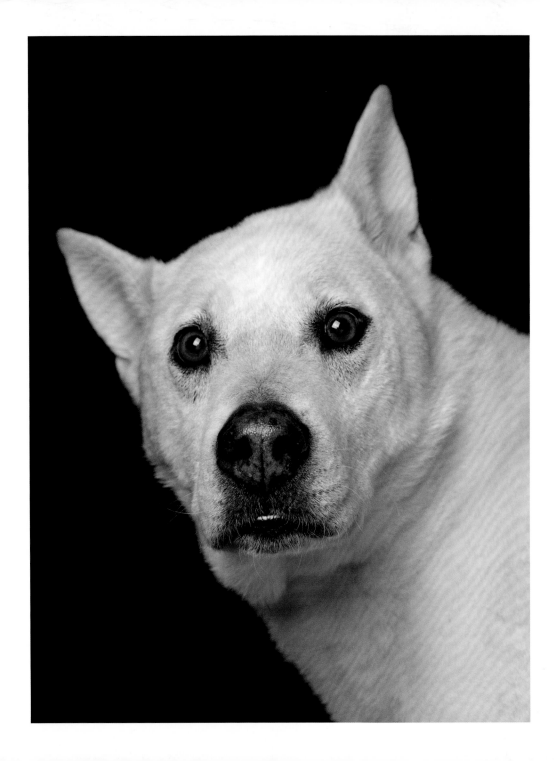

Enzo

JINDO

Enzo carefully examines each toy from his collection before selecting one.

His favorite is Best Friend, an old, tattered alligator, its stuffing long gone.

But Enzo doesn't mind. He loves his reptilian pal just the way he is.

Best Friend is his best friend.

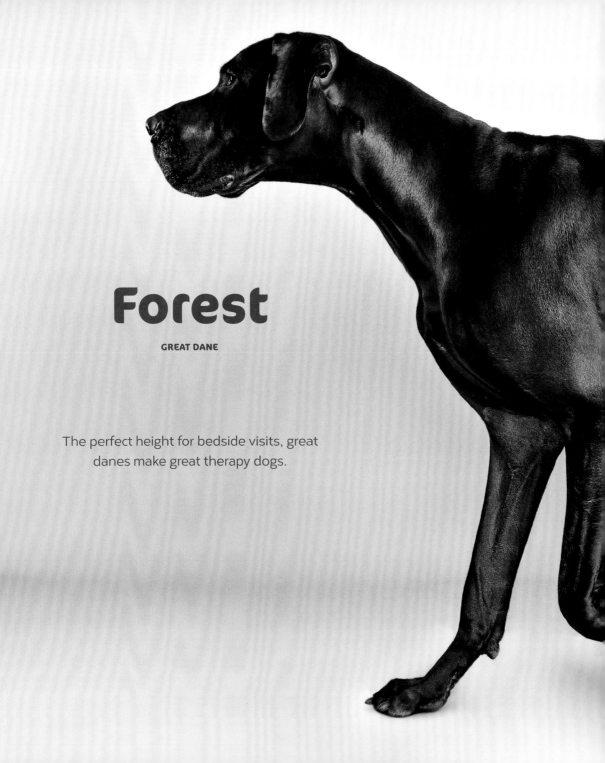

Forest

GREAT DANE

The perfect height for bedside visits, great danes make great therapy dogs.

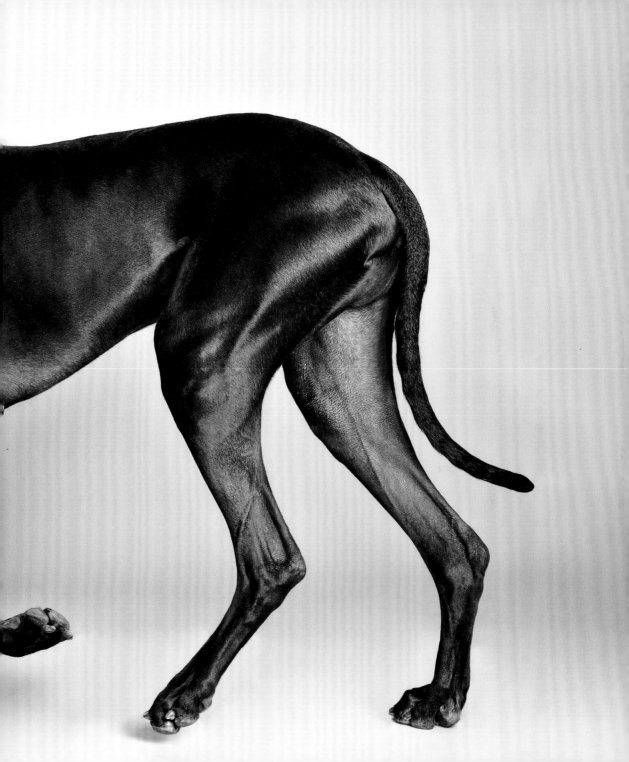

Hutton

LABRADOR RETRIEVER

At Warrior Canine Connection, combat veterans aid in the therapeutic mission to train service dogs for fellow soldiers. After two years of rigorous training, Hutton was ready to be paired with his human, Jonathan.

The injuries Jonathan incurred in Afghanistan left him with mobility and memory issues, but the strong, alert, and steady dog provides physical and emotional support. Jonathan now navigates the world more confidently with his trusty copilot, Hutton, by his side. Roger that.

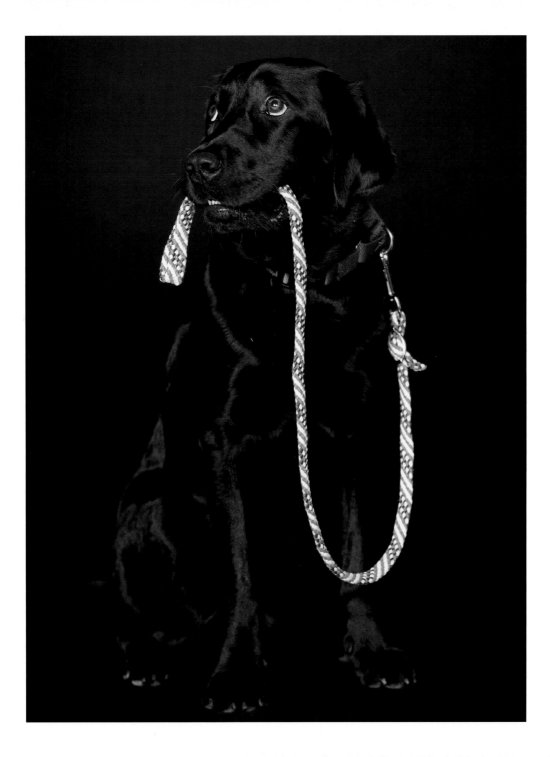

Arlo

GOLDEN RETRIEVER

Emotional support animal and sock thief.

Everyone has a dark side.

Fozzie

ELKHOUND/GERMAN SHEPHERD MIX

A giant fuzzy moth who eats holes through all the blankets.

Mochi

BORDER COLLIE/JACK RUSSELL TERRIER MIX

A common housefly causes a glitch in his matrix.

Transfixed on the buzzing insect, he barks, demanding it be killed and fed to him.

Stay weird, Mochi.

Malcolm

MUTT

He's Canadian, so he's just a real nice guy.

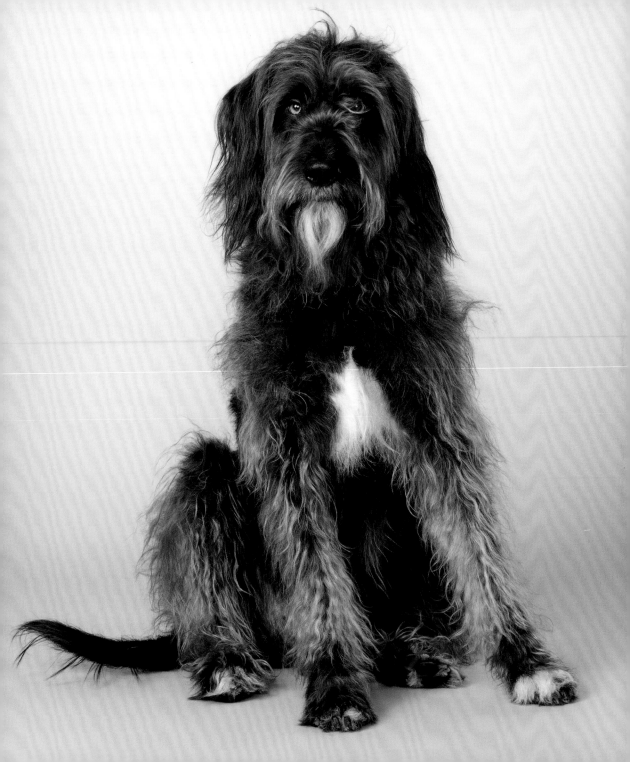

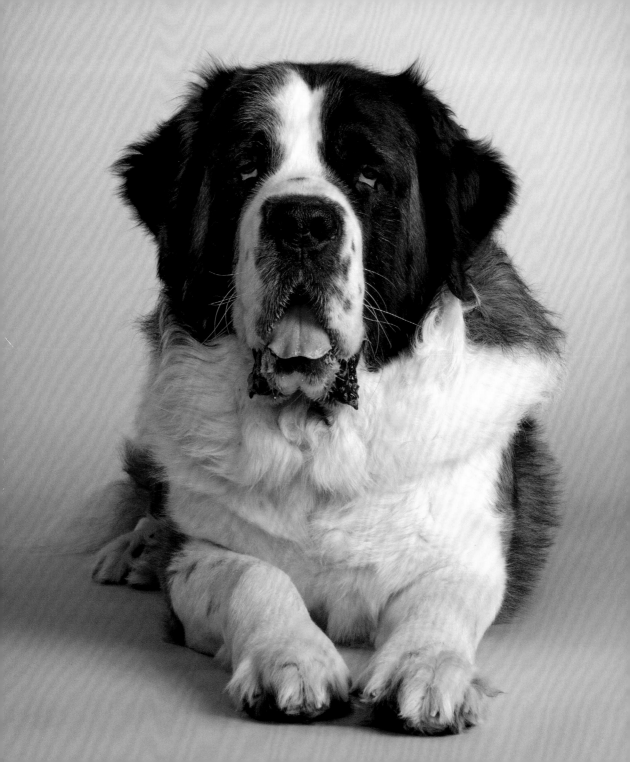

Max

SAINT BERNARD

The breed is famous for finding avalanche victims
buried under deep snow.

If you want to find dog slobber on your ceiling,
get a Saint Bernard.

Kieran

GREAT DANE

Designer Mary Douglas Drysdale has always had a great dane by her side as both wingman and muse.

Over the past thirty years she and her dogs have graced the pages of *House Beautiful* and other interior design magazines.

Strolling through D.C., the two turn heads wherever they go.

"It's like walking down the street with Brad Pitt."

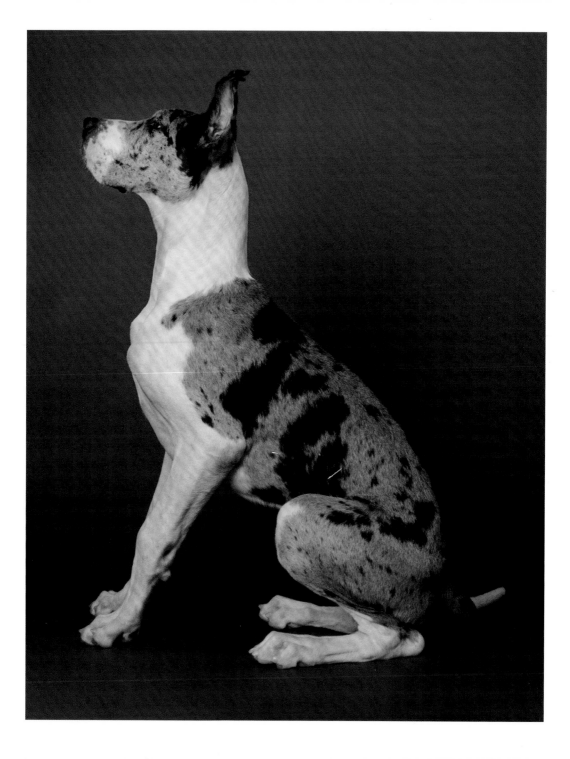

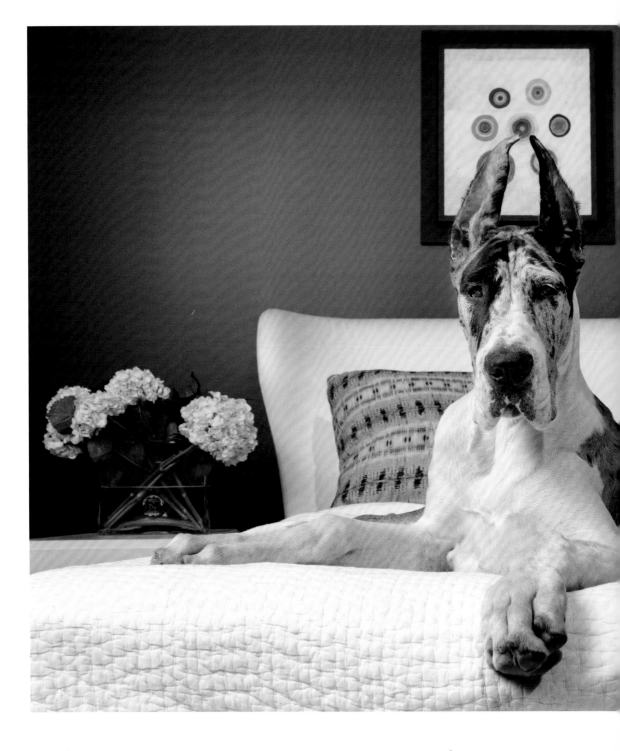

Hans

BERNESE MOUNTAIN DOG

This hunk may give off an all-brawn, no-brains
vibe, but he's smart enough to fake a limp
to get out of a long hike. Heck, he may even
be a genius.

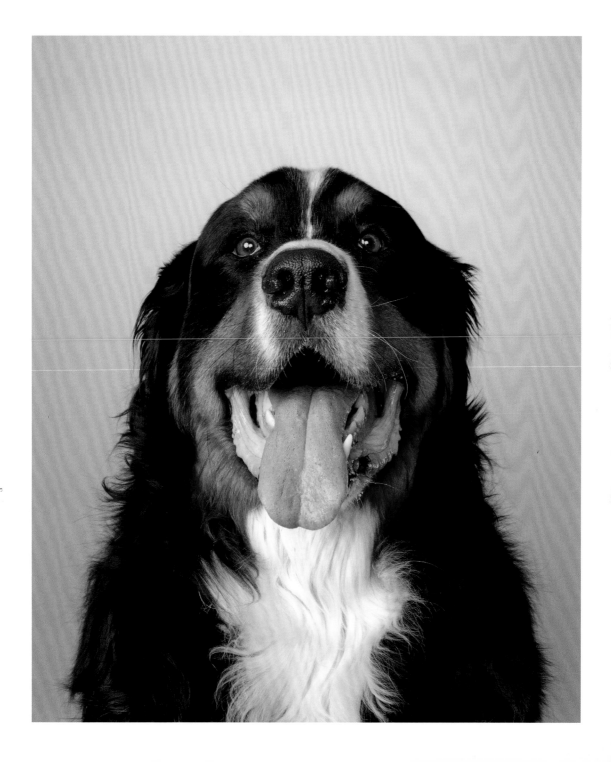

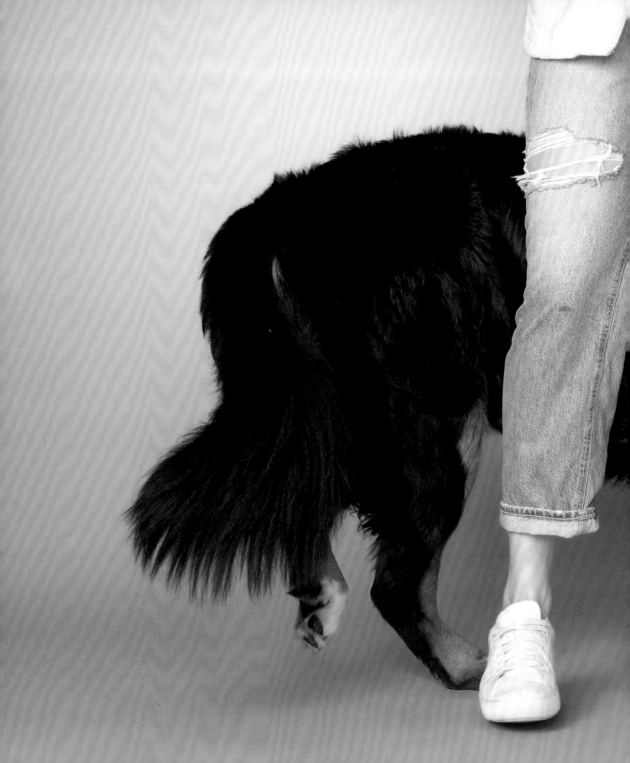

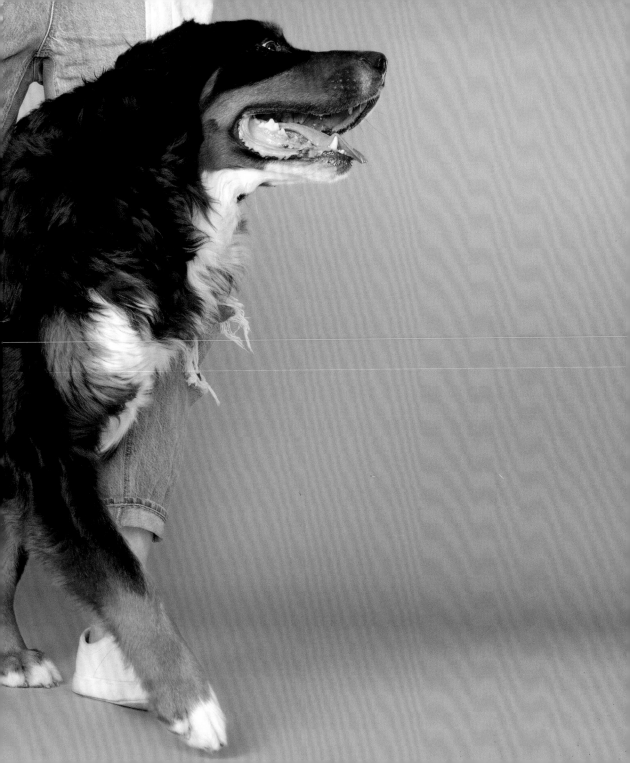

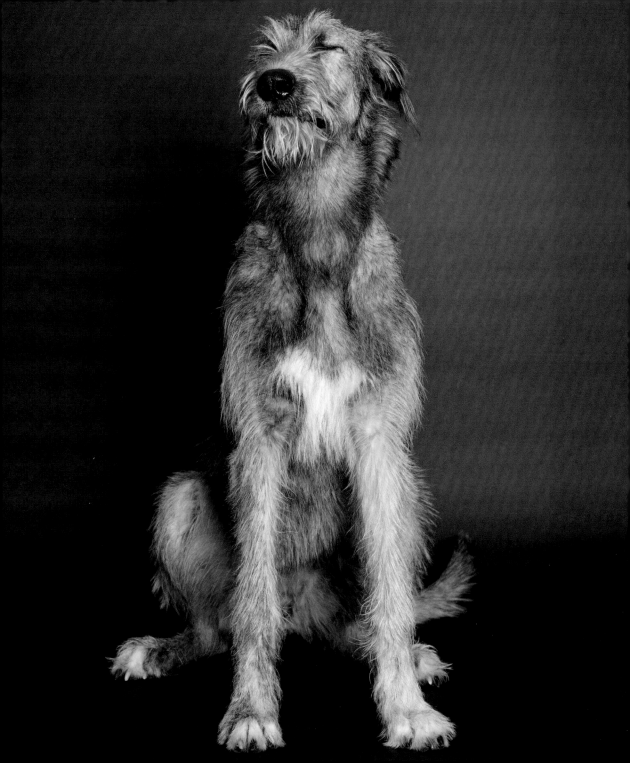

Maeve

IRISH WOLFHOUND

All AJ wanted for Christmas was a pair of light-up Power Rangers sneakers, like the ones the other kids in his class were wearing. But he'd never have them. His feet had grown so fast that they already fit into adult shoes. He towered over everyone he knew.

One day after school, big AJ was sitting on the regular-size couch watching TV when a program about dogs came on. It was then that AJ first laid eyes on an Irish wolfhound, easily twice the size of any dog he had ever seen, and felt a jolt run through his quickly growing body. He listened closely as the narrator listed some of the breed's attributes: the world's tallest dog; kind, calm, and thoughtful, despite their size. AJ felt an immediate connection.

In high school, he finally got his first Irish wolfhound. He saw a lot of himself in the dog, but he also observed and admired how confident the pup was. Caring for him allowed AJ to love and accept himself with a newfound maturity and grace. He's had an Irish wolfhound by his side ever since.

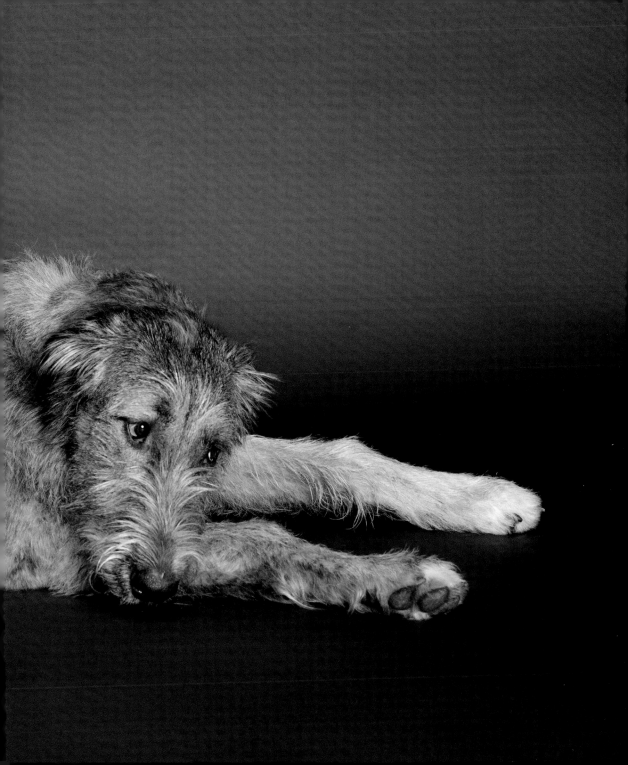

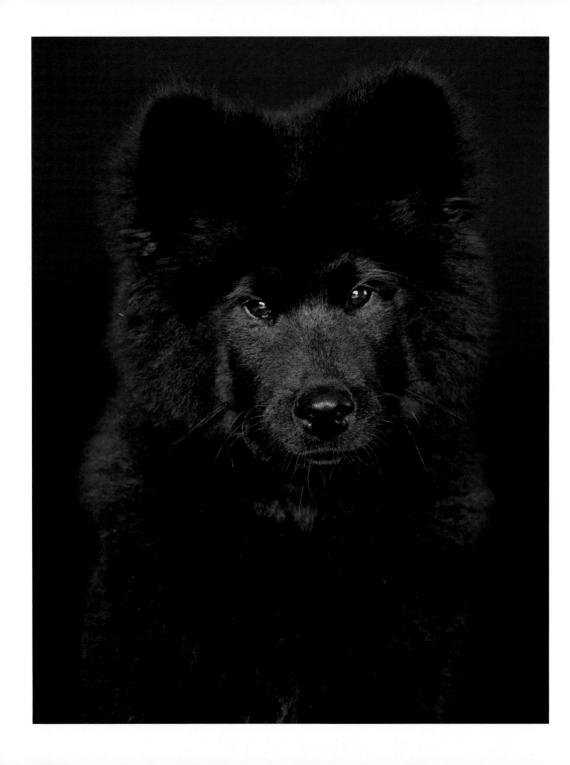

Malmok

EURASIER

An old soul in a puppy body.

This black bear cub is heaven sent.

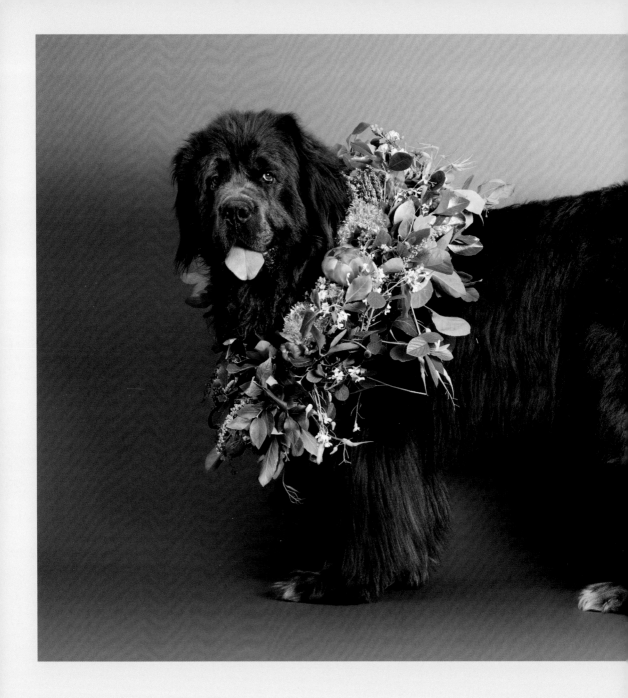

Boone

NEWFOUNDLAND

Rabbit chaser, lifesaver, right-hand man.

After Peggy's divorce, this big lug helped her start a farm and find her flower power.

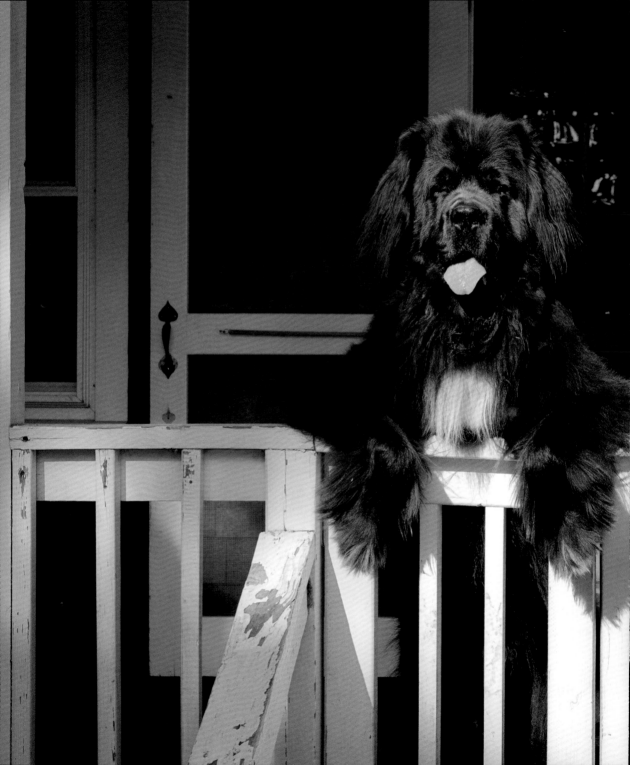

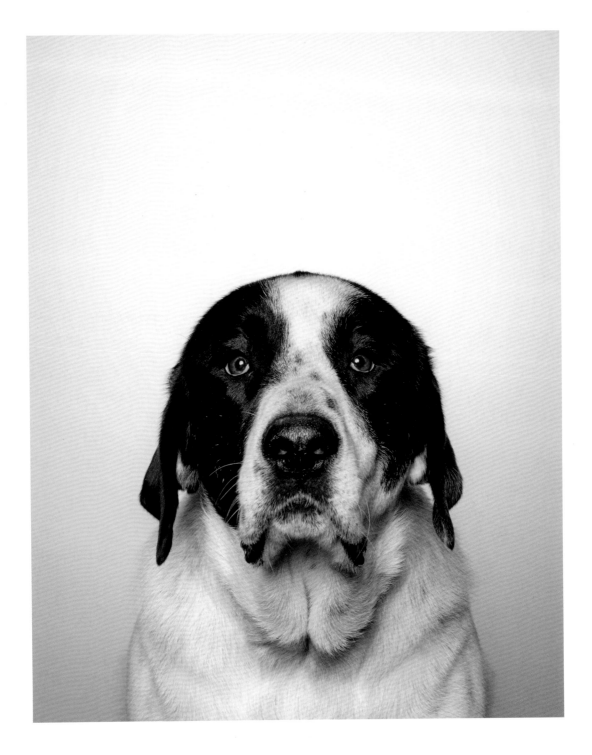

Phillip

TREEING WALKER COONHOUND/GREAT PYRENEES MIX

Loves going on dump runs with Grandpa.

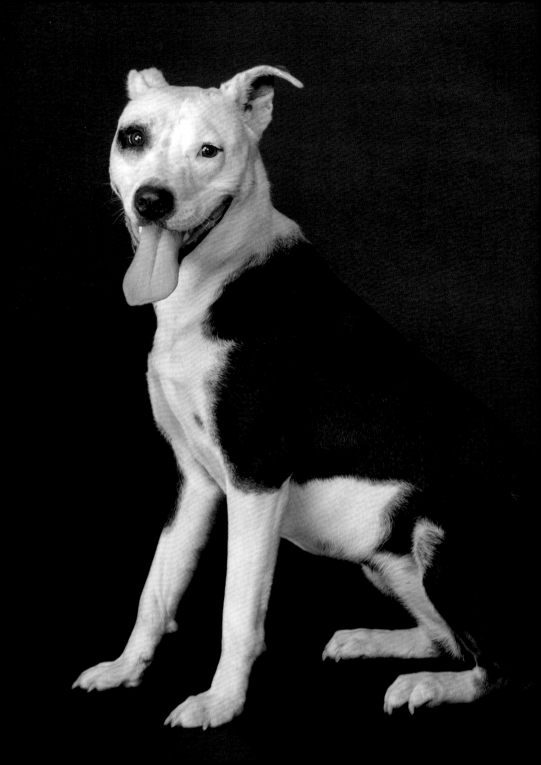

Bella

AMERICAN PIT BULL TERRIER MIX

Bella was being ripped apart by stray dogs when a
Good Samaritan stepped in and saved her life.

Several surgeries later, she was transported from
Mississippi to a rescue in Maine and put up for adoption.

For more than twenty years Johanna had been
pining for a dog.

It had never been the right time.

But after hearing Bella's story, she and
her husband took a chance.

On a cold winter night, they met.

Bella was a tornado of unfettered love and
boundless energy.

She leapt into their arms and stole their hearts.

The search was over.

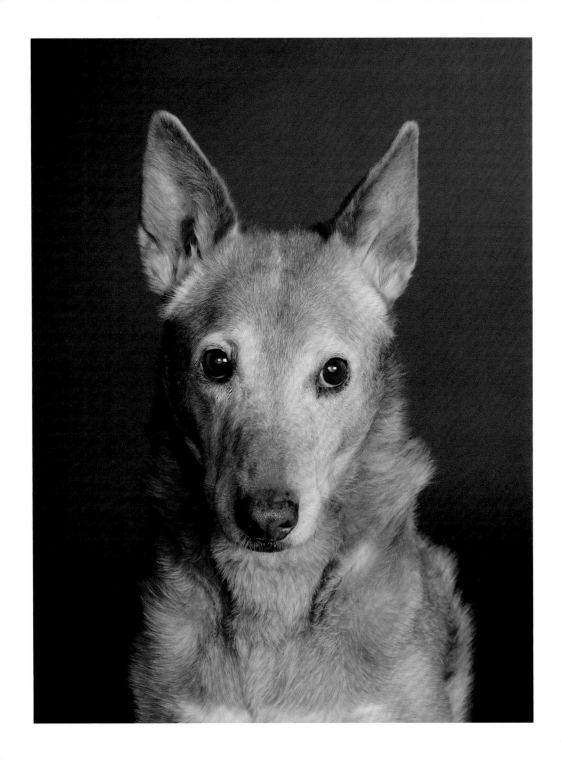

Mailbox

PHARAOH HOUND MIX

Abandoned at an animal shelter, tied to the mailbox.

When she was adopted by a horse vet who knew how to treat her right, this girl's luck took a turn for the better.

"The Box" spent fifteen glorious years riding shotgun on farm calls.

Giddyup!

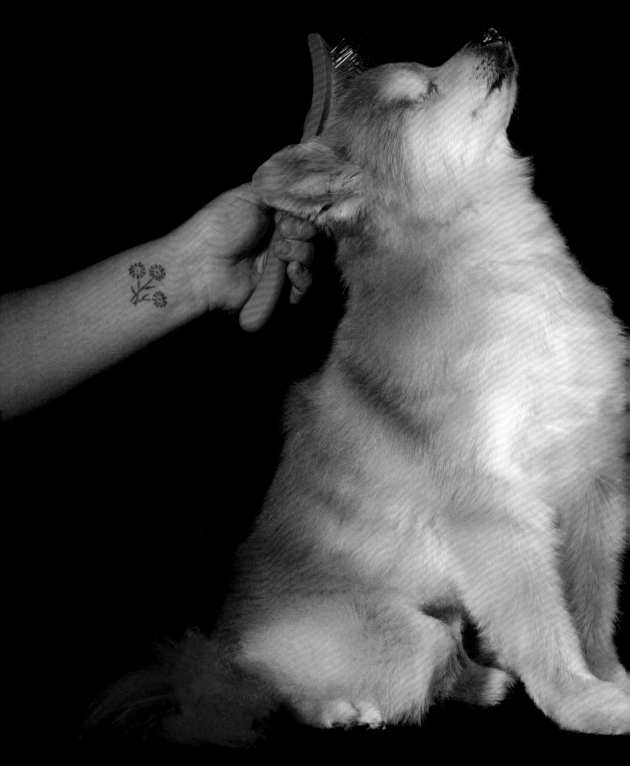

Whiskey

POMERANIAN

When a writhing Tasmanian devil was placed on Lydia's grooming table, it took her a moment to realize that the ferocious dust ball was in fact an old, filthy, blind pomeranian.

Rescued from a dire situation and brought into the animal hospital, this fella needed a bath. As Lydia began to lather the shampoo into his matted fur, she saw that his skin was crawling with more fleas than she'd ever seen in her entire grooming career. She knew no one would want to foster, let alone adopt, this ornery senior, and she decided to take him in.

Back home, the sightless pom walked into furniture and walls like he was drunk. Lydia named him Whiskey. The two began working on voice commands and creating a safe space. Knowing that he'd been living in severe and unnecessary pain for years, Lydia and her vet made the critical decision to remove Whiskey's eyes.

After the surgery, Whiskey was a changed dog. To everyone's surprise, once he was pain-free, he was no longer aggressive. He strutted around with confidence and greeted Lydia with spins and tip-taps before melting into her arms and licking her face. Now that he loves getting brushed, Lydia dotes on him with fancy, funky dyed hairdos.

Lydia has her own eye issues; she was diagnosed with diabetic retinopathy years ago, and the disease has progressed. Witnessing Whiskey's transformation and his ability to adapt and flourish has given Lydia the courage to deal with the possibility of losing her own sight. Sitting in the doctor's chair, she repeats to herself: *If Whiskey survived this, so can I.*

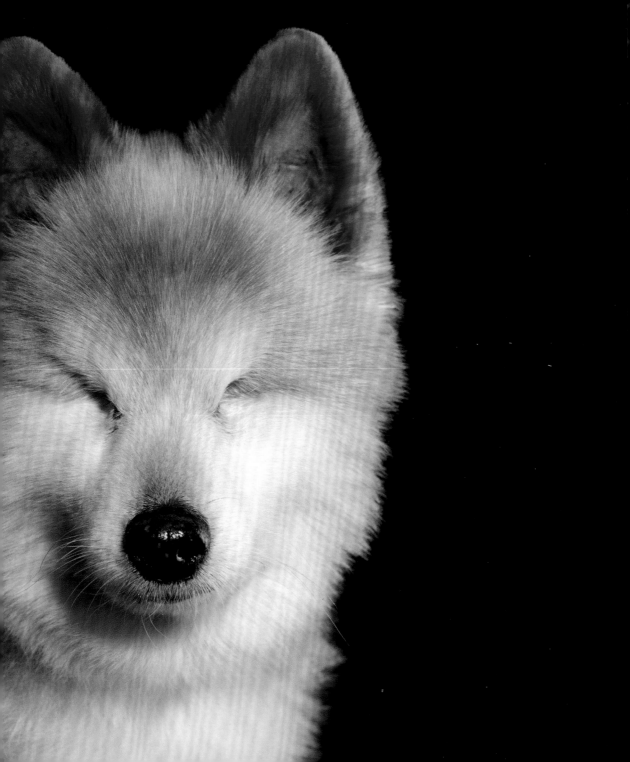

Sawyer

AFGHAN HOUND

His ancestors slayed leopards in the rugged Afghan mountains. Sawyer slays in the show ring. He's a natural beauty who (besides the two-hour blowout) woke up like this.

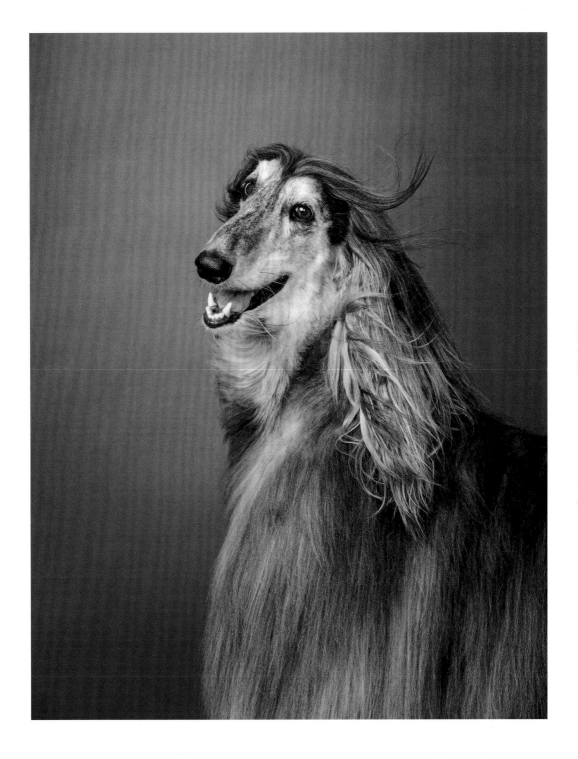

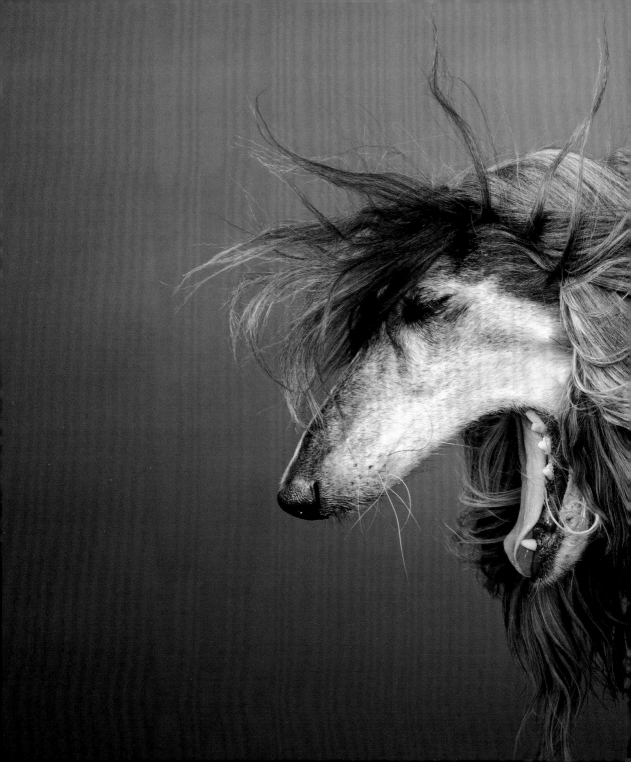

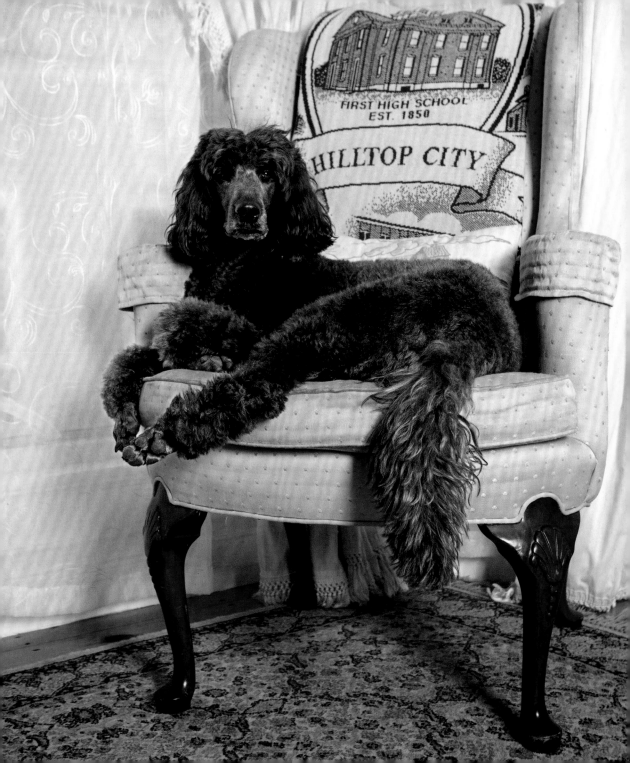

Wojtek

GOLDENDOODLE

To poodle the doodle or not to poodle the doodle?

That is the question.

Doodles are poodle crosses that have exploded in popularity in recent years. There are labradoodles, bernadoodles, schnoodles, goldendoodles, and more.

Most doodle people choose not to get their doodle groomed like a poodle, preferring the full-coated, shaggy, teddy bear look.

But Maddie and Aaron love the cleanly shaved face and coiffed locks of the classic poodle hairstyle.

Their answer to the question is always: Yes, please poodle my doodle.

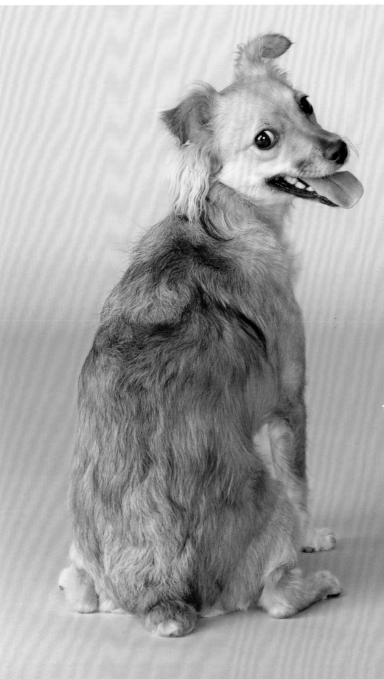

Betty

TOY COATED XOLOITZCUINTLI

A Mexican hairless
dog with a full coat
of hair who doesn't
speak Spanish?

She may be an
oxymoron, but she's
an awfully good girl.

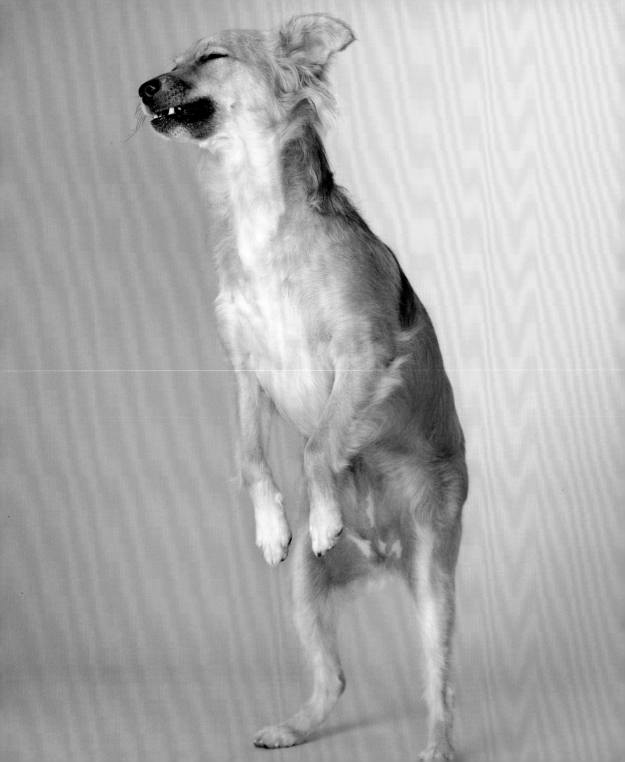

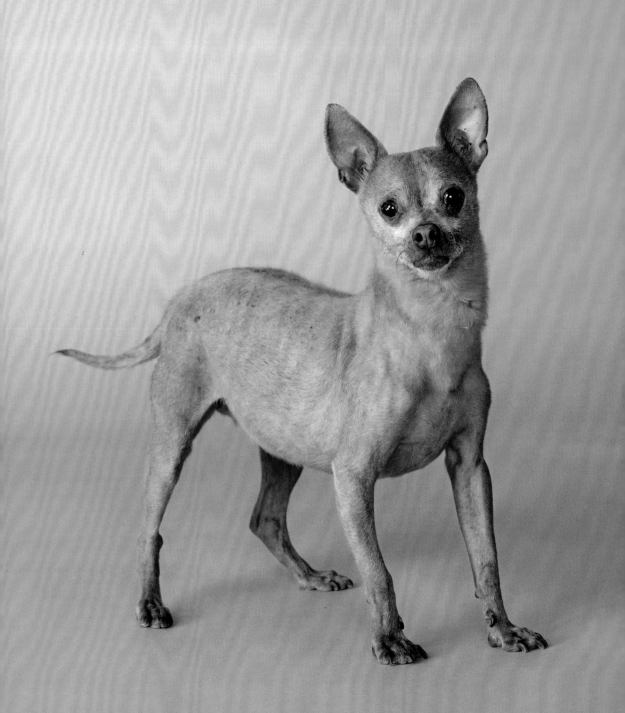

Franklin

XOLOITZCUINTLI MIX

Aztecs revered Xoloitzcuintli as guides to the underworld.

Thousands of years later in an LA kill shelter, Franklin sat shivering, wondering where it had all gone wrong.

By the skin of his tiny teeth, he was saved by a dog rescue group but still needed to find a forever home.

Days turned into weeks. Weeks into months.

In a last-ditch effort, the rescue group posted a video to Instagram. Holding the hairless angel up to the camera, they lamented that not one soul had applied to adopt him. No one wanted Franklin. Taylor saw the video and that night she cried herself to sleep.

She woke up knowing that *she* wanted Franklin more than anything.

A year later, he was the best man at her wedding.

In the summer of 2022, the Humane Society led one of the largest animal rescue efforts ever: the removal of four thousand mistreated beagles from a breeding facility in Virginia. The dogs had never left their small crates. Filthy, neglected, and malnourished, many were bound for a life of animal testing.

Dozens of the floppy-eared mini sniffers were scooped up by the Northeast Animal Shelter in Salem, Massachusetts, just one of the many rescue organizations to step up and help.

Four thousand beagles once bound for a life of suffering are now living their best lives in homes across the country.

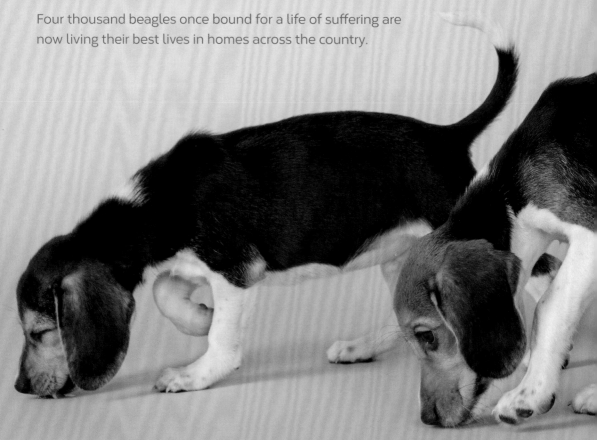

Hazely Runa Touché

BASSET HOUND

The stubbiest legs.

The longest bod.

The droopiest ears.

The flubbiest flub.

The howliest howl.

The bassitude is real.

The whole package, irresistible.

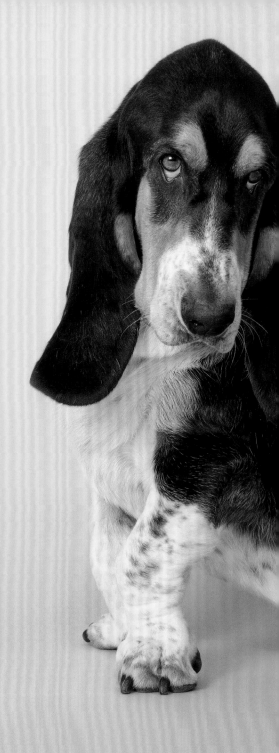

Addie

AFGHAN HOUND

Between six months and two years old, dogs are teenagers. They're hormonal, seek independence, listen to loud music, and miss curfews. Addie's got big feelings and she's running for student council.

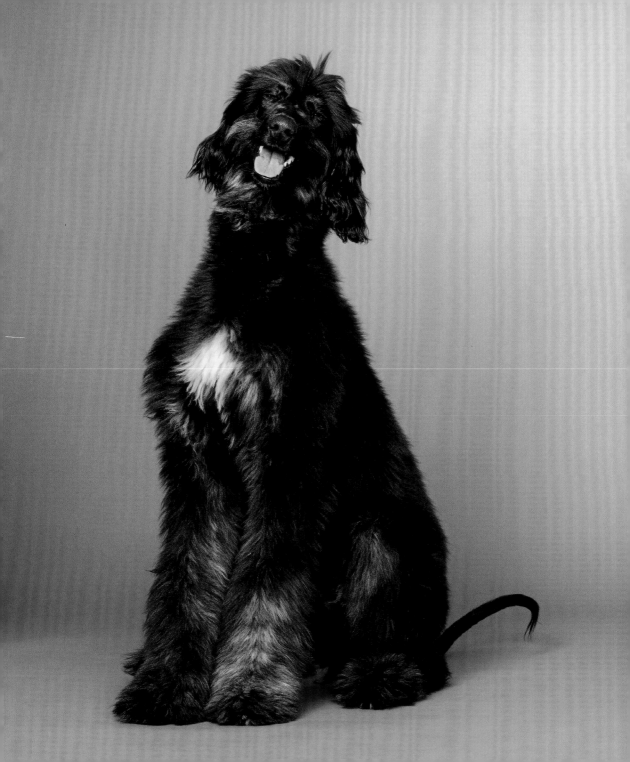

Bear

LABRADOR RETRIEVER

The friendly mayor of Tilton Ave.

He parades down the block flanked by three cat bodyguards, stopping to visit every neighbor along the way.

Rumor has it, he's easily bribed with treats.

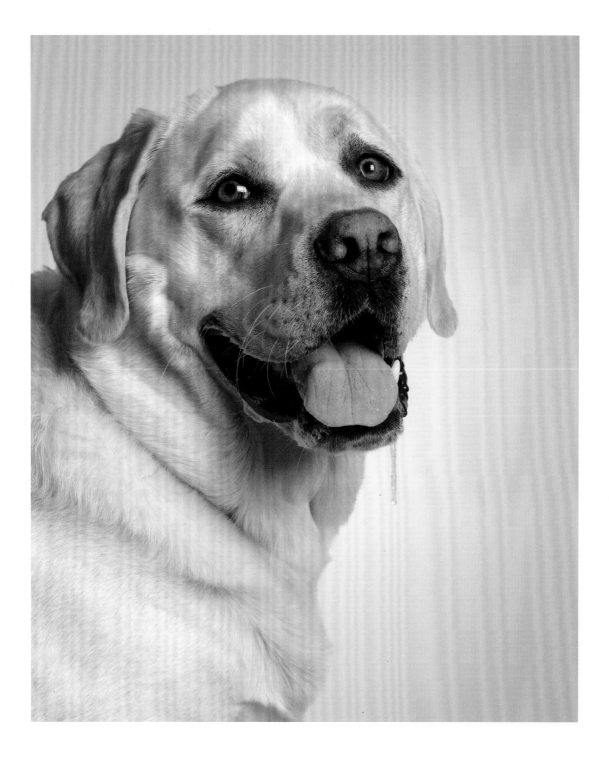

Aldo

WIREHAIRED DACHSHUND

Aldo is hired to track the scent of injured
moose, bears, and other wildlife in the
dense brush of the north Maine woods.
When his mission is accomplished, he
lets out a triumphant howl.

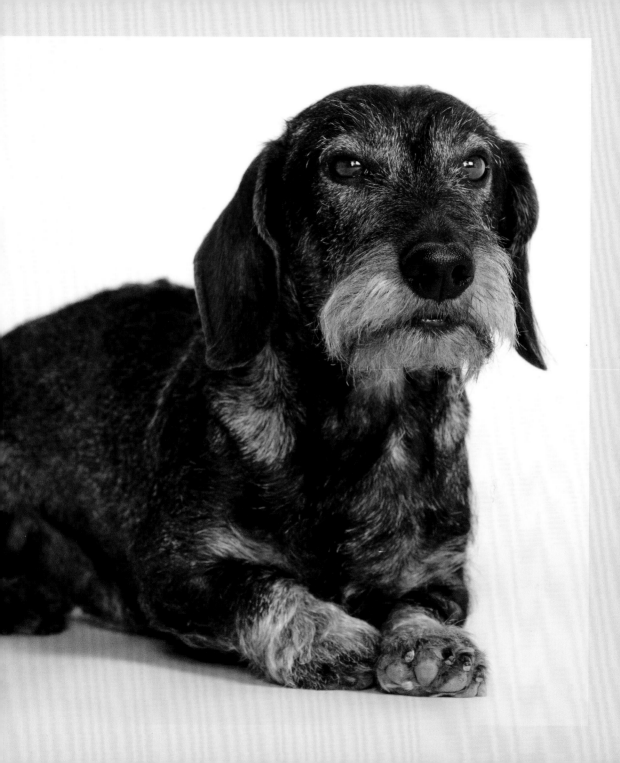

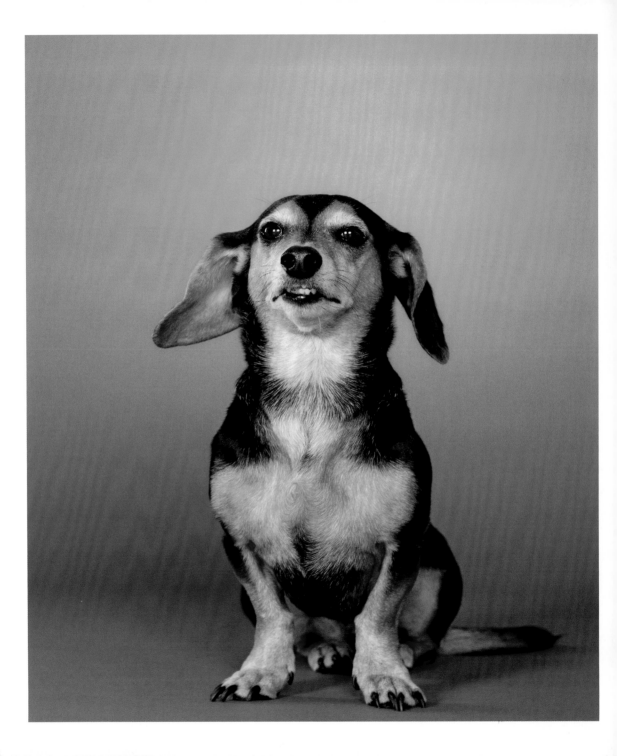

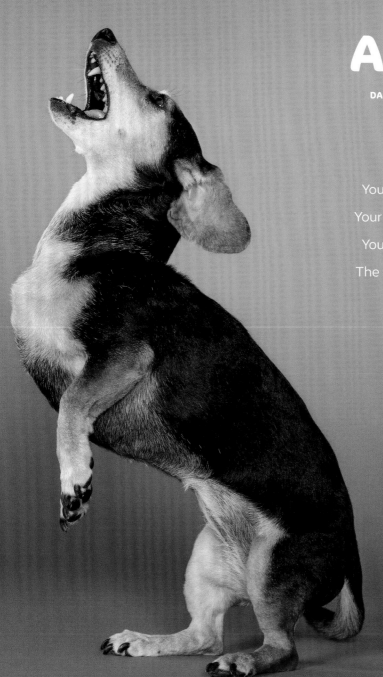

Andi

DACHSHUND MIX

Your lap is hers.
Your lunch is hers.
Your job is hers.
The world is hers.

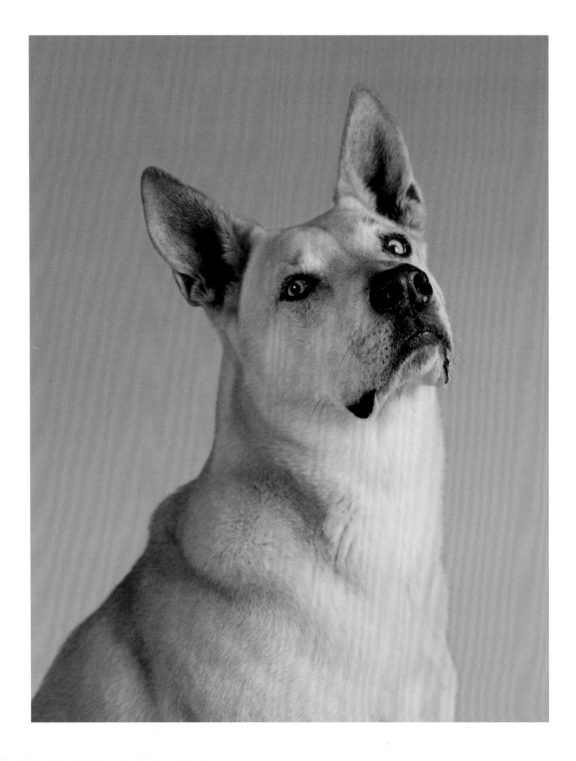

Chuck

HUSKY/AMERICAN PIT BULL TERRIER MIX

Not only did dog-obsessed, true crime–obsessed Ashley Flowers name her production company audiochuck after her beloved dog, but his howl can also be heard at the end of every episode of her chart-topping podcast, *Crime Junkie*.

If you visit audiochuck's office in Indianapolis, it's as if Chuck knows his name is on the wall. You'll find him contentedly napping in a sunny spot, asking for butt scratches, or silently judging you during a production meeting—like a real boss.

With icy blue eyes that can give you full-body chills, Chuck is doing his best to be weird, be cute, and stay a good boy.

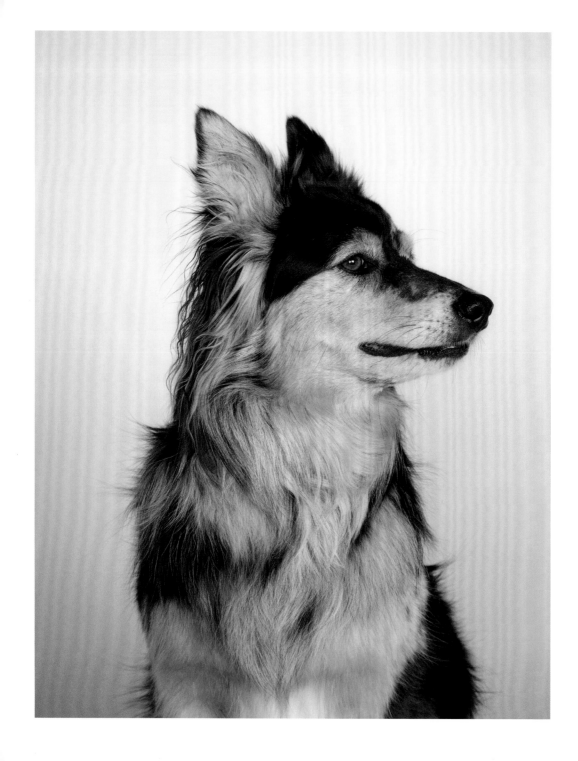

Delta

AUSTRALIAN SHEPHERD

This die-hard conservationist is better at her job locating endangered wood turtles than any human scientist.

Paid in games of fetch, she's always willing to work overtime.

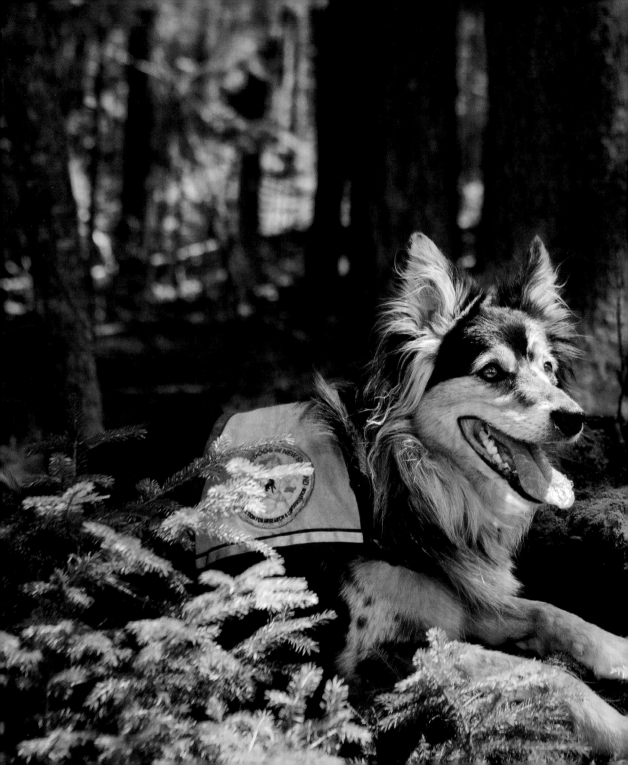

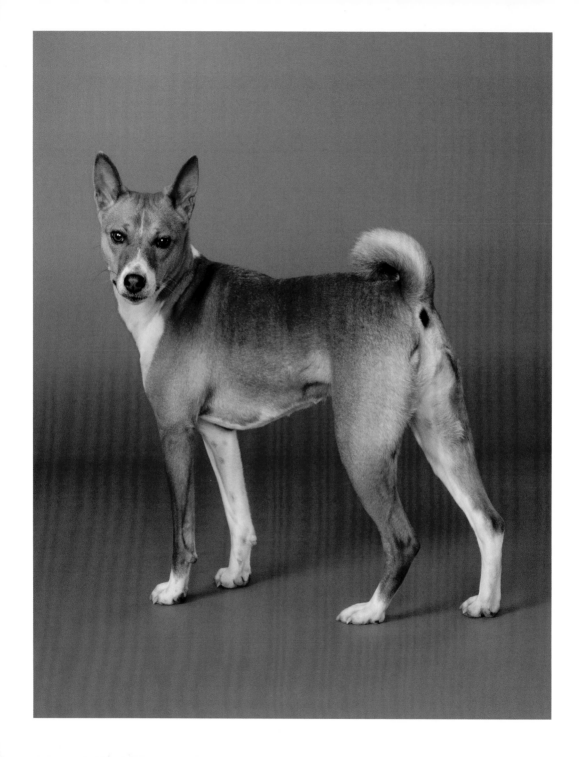

Charlie

BASENJI

Anthony loves a troublemaker.

Along came Charlie, with her wrinkled forehead and curled tail, the basenji-est basenji.

This African breed's curiosity, agility, and energy lead to mischievous adventures that could send even the most ardent dog lover running for the hills.

But for Anthony it seals the deal.

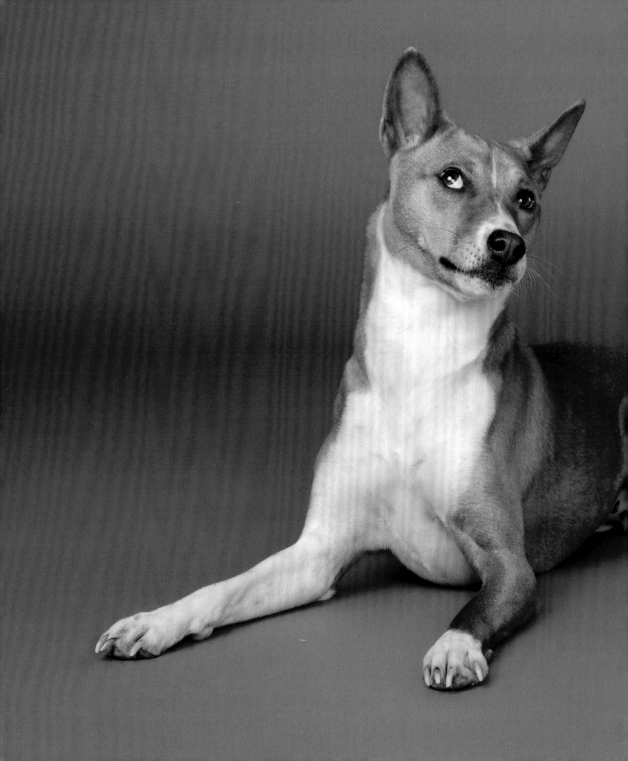

Stella

PAPILLON

To protect her precious papillon from predators,
Judy, a retired postal worker, carries a baseball
bat and an air horn on their walks. If anyone
wants to snatch her baby, they're going to have
to go through her first.

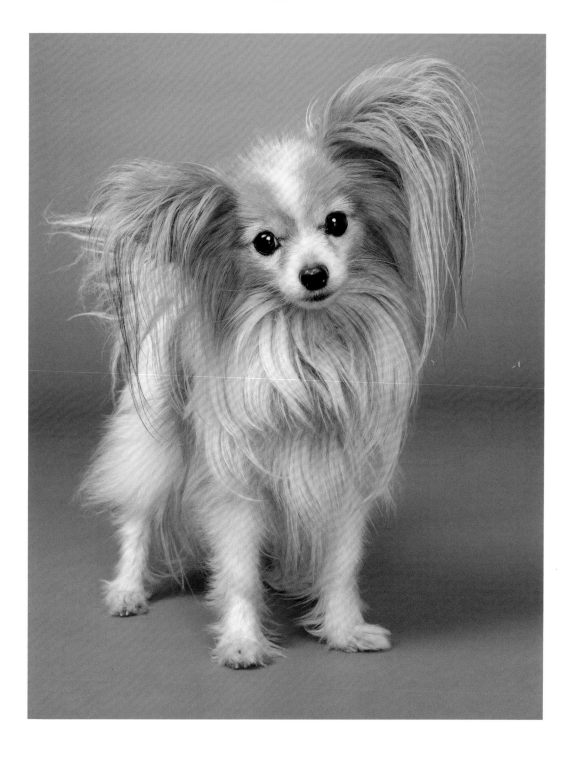

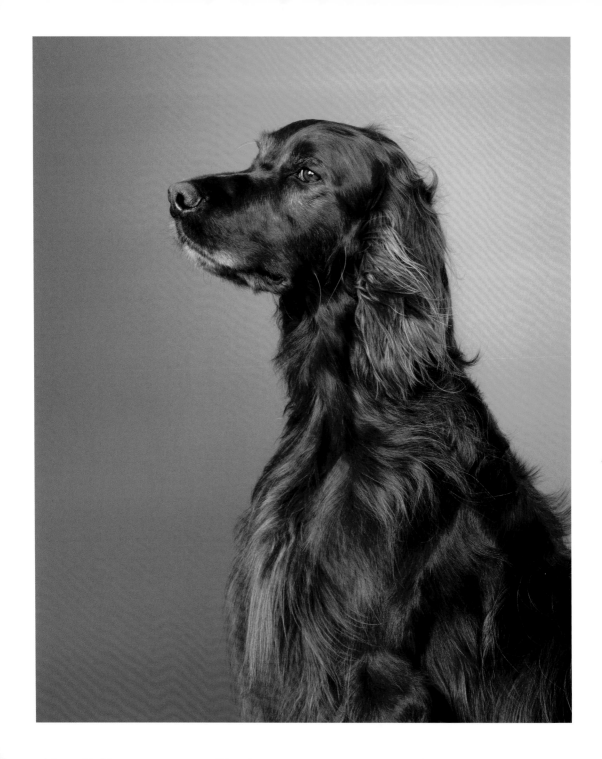

Guiney

IRISH SETTER

This handsome package once snuck aboard a UPS truck for a quick adventure.

He was returned to sender by the surprised driver before anyone at home even noticed he was missing.

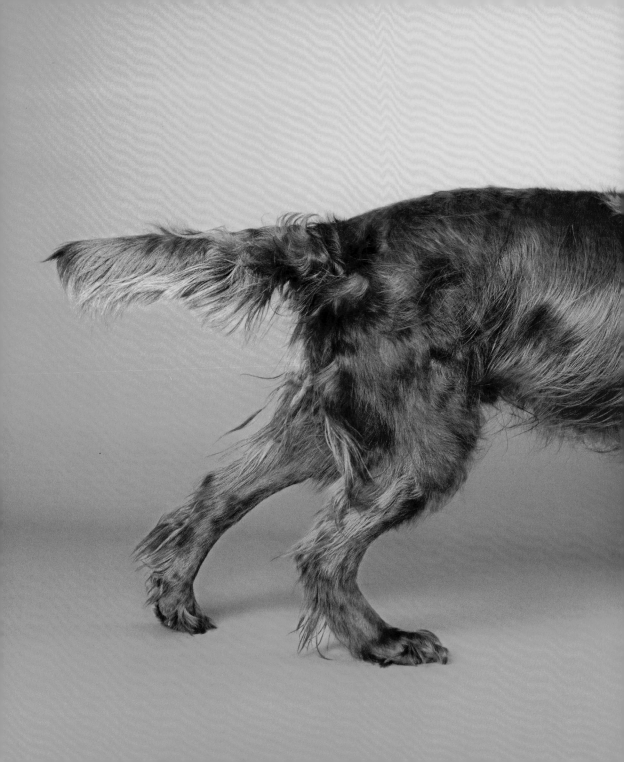

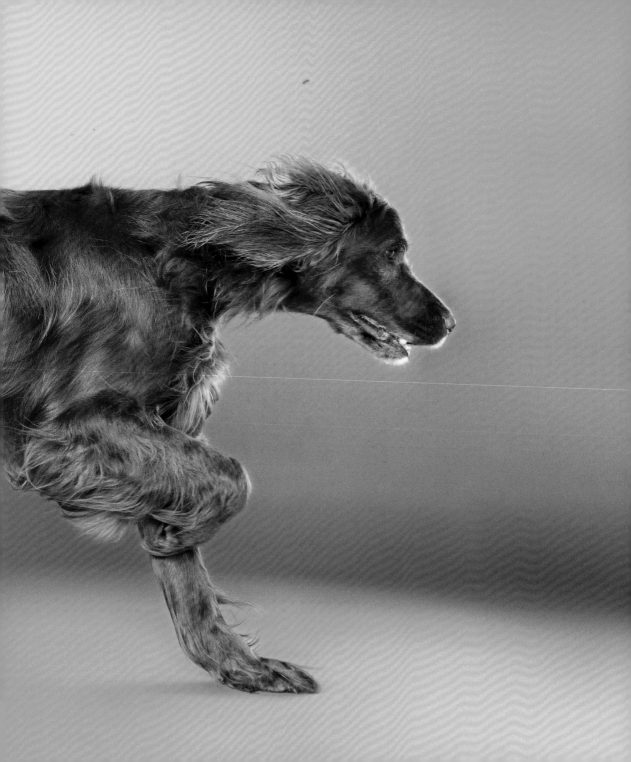

Vinnie

YORKSHIRE TERRIER

A pickpocket who will steal your money and your honey.

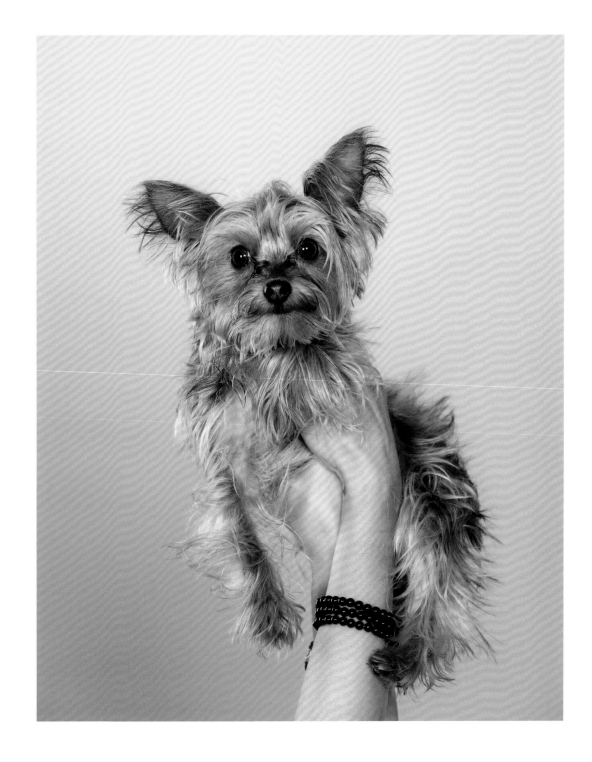

Lola

WEST HIGHLAND WHITE TERRIER/CHIHUAHUA MIX

Uptown girl . . .

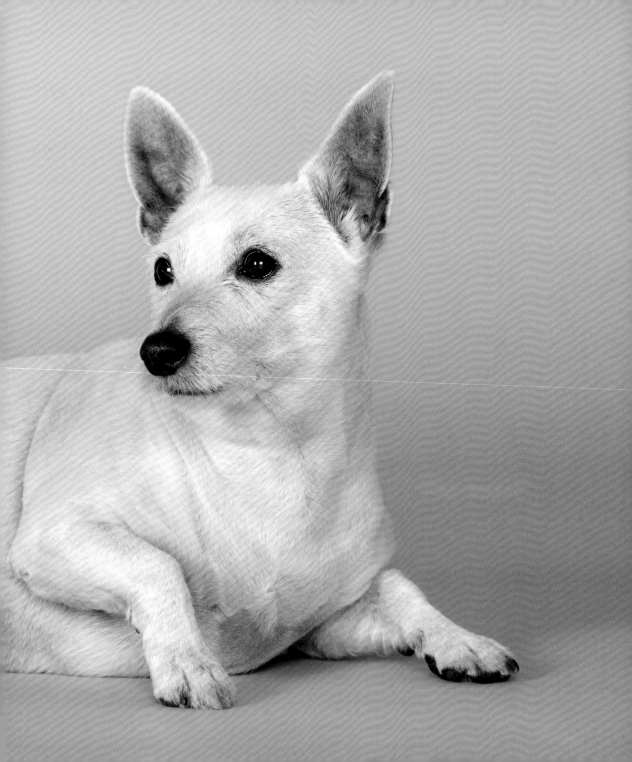

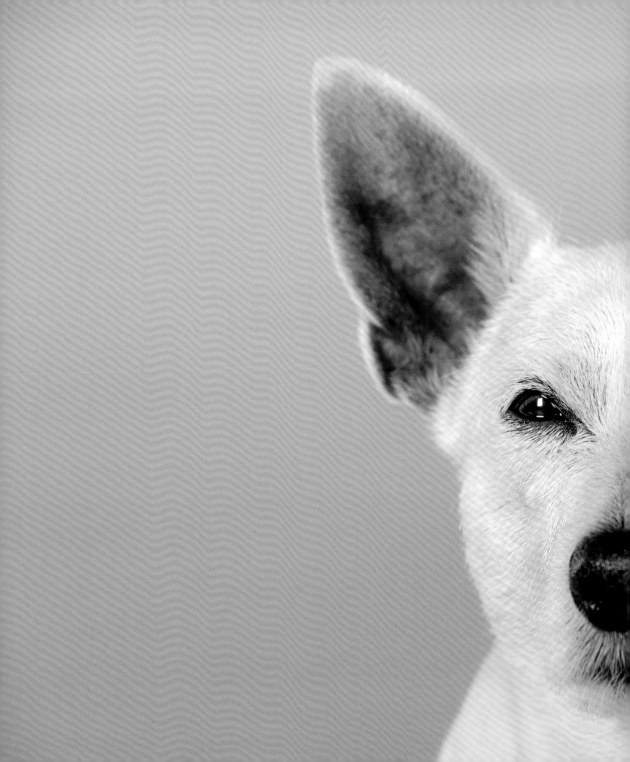

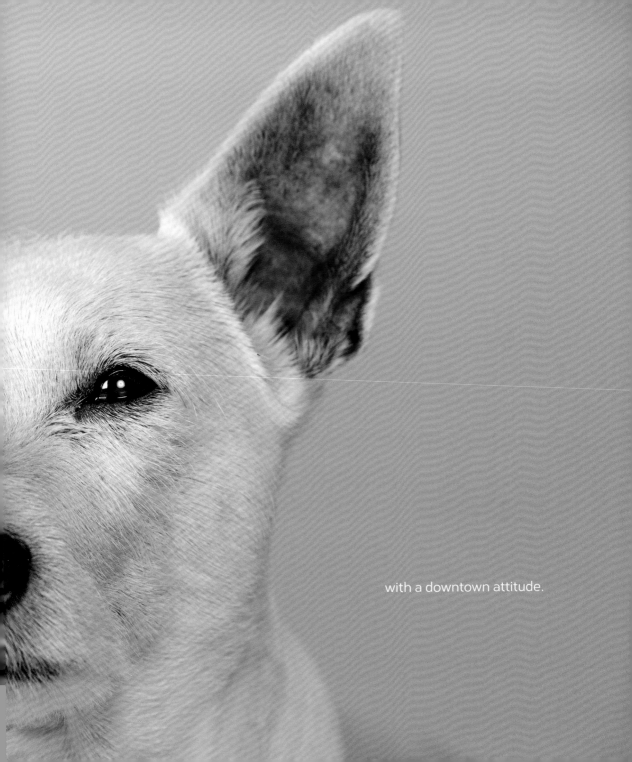

with a downtown attitude.

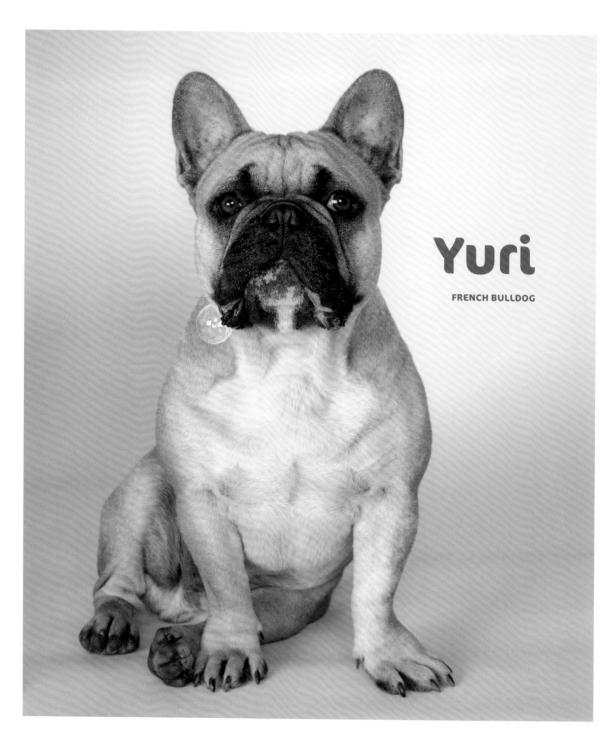

Yuri

FRENCH BULLDOG

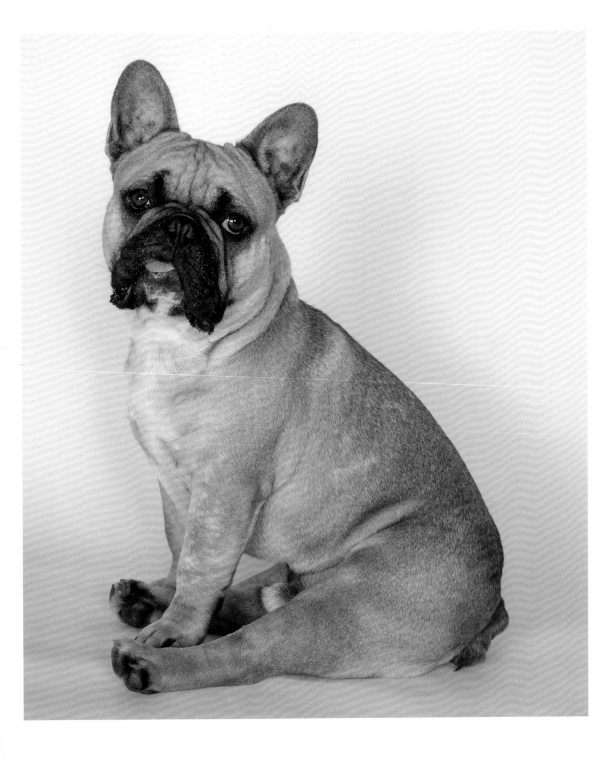

Slapstick is his shtick.

Caper

ENGLISH BULLDOG

Small, round, salty

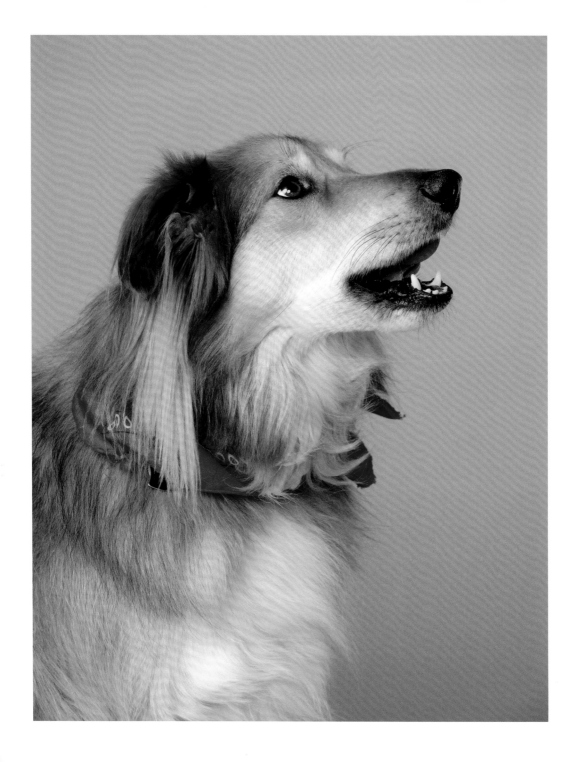

Jax

OLD TIME SCOTCH COLLIE

Cheese curls are his Kryptonite.

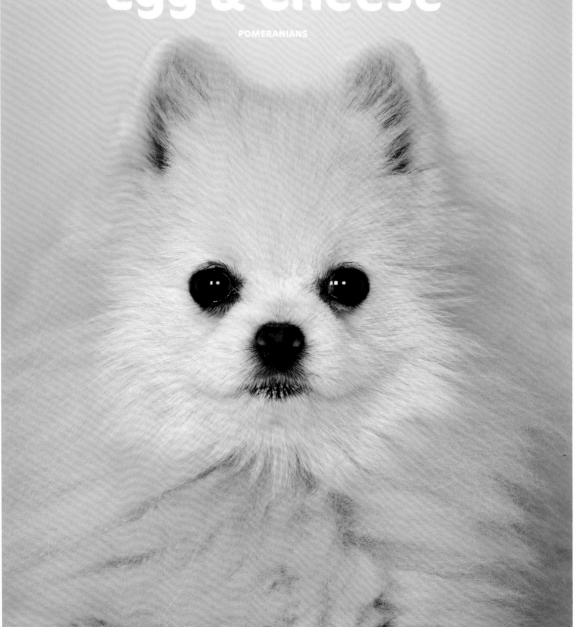

Egg & Cheese

POMERANIANS

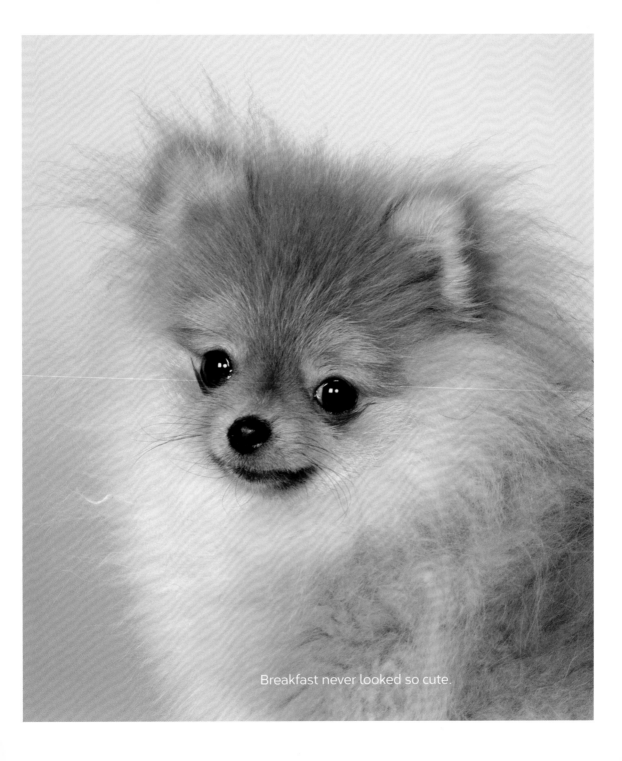

Breakfast never looked so cute.

Potato

PEMBROKE WELSH CORGI

This small fry comes with a shake.

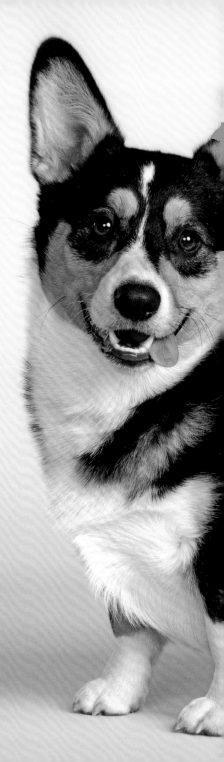

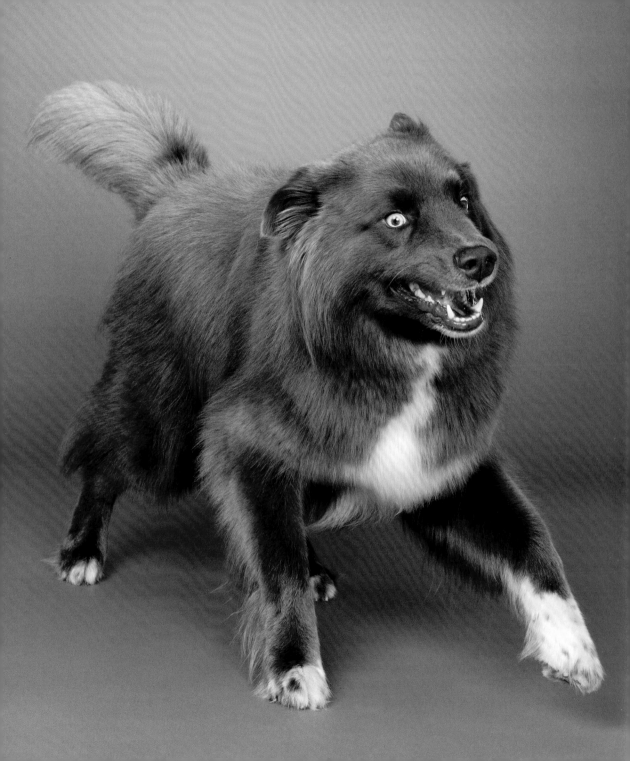

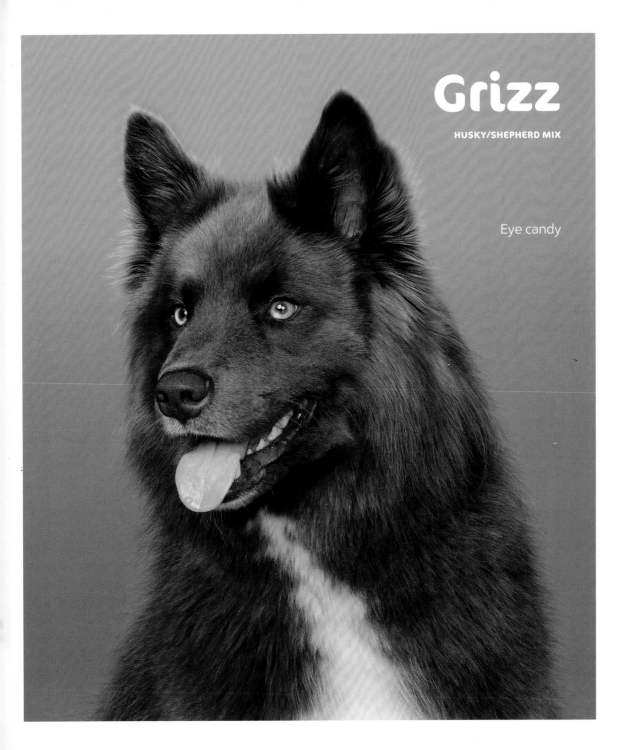

Grizz

HUSKY/SHEPHERD MIX

Eye candy

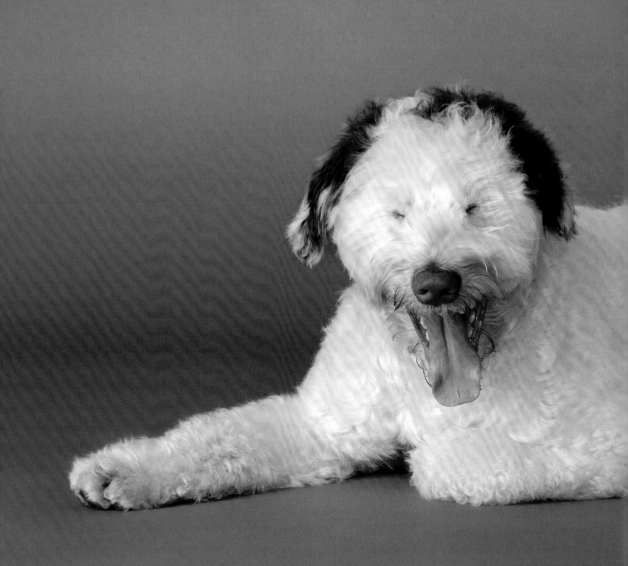

Boyd

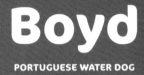

PORTUGUESE WATER DOG

Boyd turns his snout up at crumbly kibble.

As for biscuits?

Blech! Bland and boring.

This gourmand delights in much finer foods, demanding
hand-grated Parmesan on every meal.

Buon appetito, Boyd.

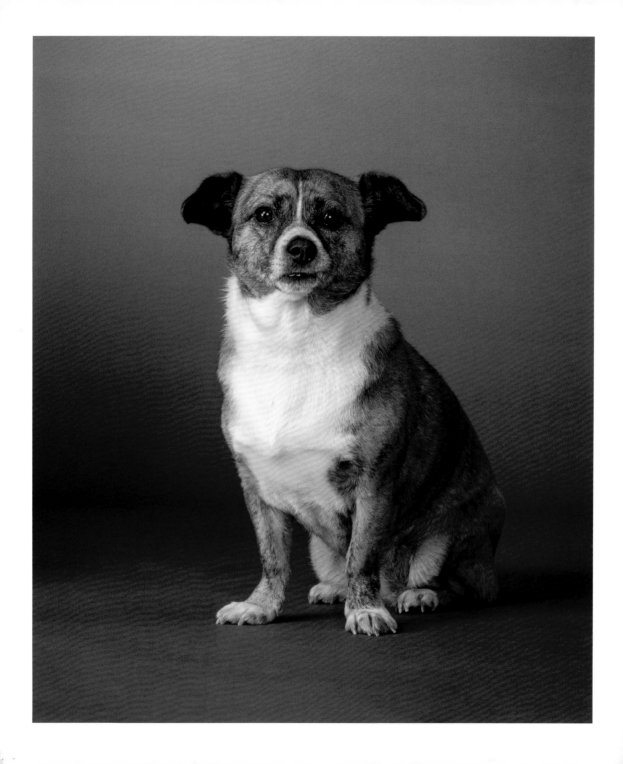

Rigby

CHINESE VILLAGE DOG

After Rigby escaped to a secret hideout and traveled twenty-four hours to a safe house, her rescue from the global meat trade was a success.

The little pup made her way to the United States, where she was adopted by Lily during her last semester in college. Rigby was scared and untrusting, but she wanted to trust. You could see it in her eyes. One day Rigby bravely climbed into Lily's lap. Day by day, she transformed into a confident and spunky spitfire. The only dinner plate she'll ever see now is one that's piled high with her favorite treats.

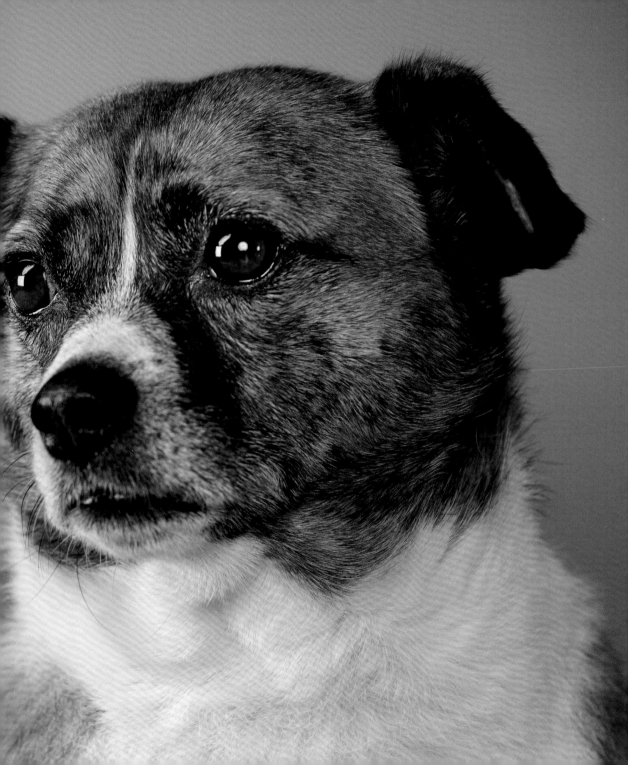

Wahala

NIGERIAN STREET DOG/MALINOIS MIX

When a wet, scared puppy was handed to Marie in Abuja, Nigeria, neither had any idea what life had in store. One turned into a lizard murderer. The other entered a doctoral program.

Across three countries, the two have lived through a global pandemic, heartbreak, healing, and many adventures.

On the great days and the not-so-great days, Marie and Wahala show up for each other.

And that makes all the difference.

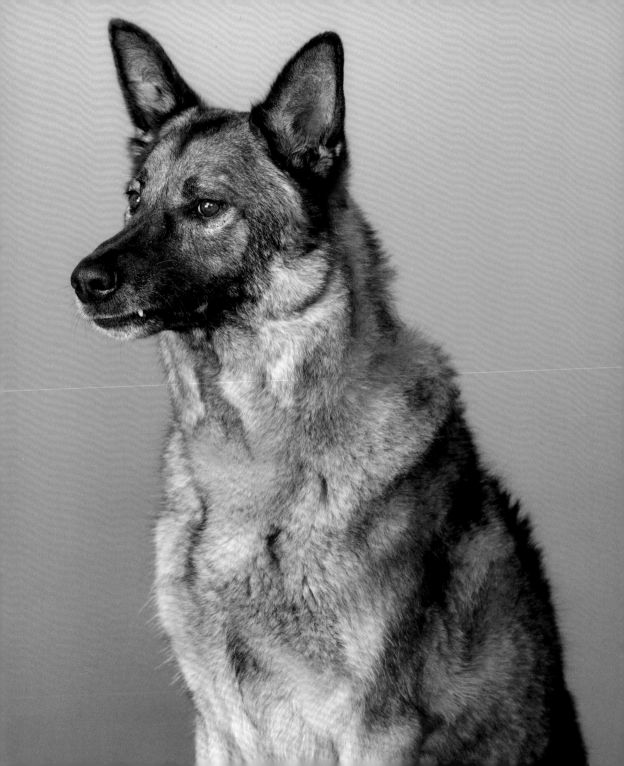

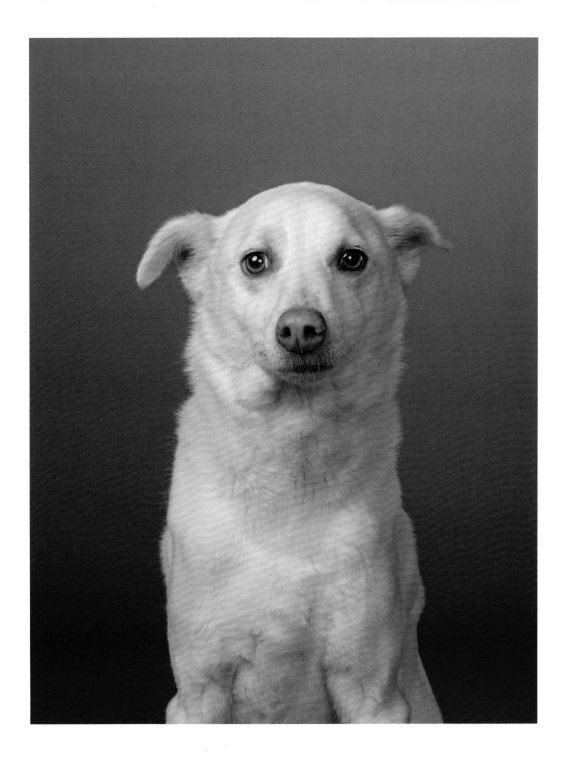

Buddy

INDIAN STREET DOG

An Indian street dog raised in America, Buddy will never know the streets of Mumbai.

The streets of Portland, Maine, are this boy's stomping ground.

Not that Buddy's much of a stomper. He's more of a fly on the wall, sitting quietly and observing. He's an intuitive empath who can sense if you're hungry, tired, or sick before you do.

He feels it all.

Thurber

BORDER COLLIE

Thurber doesn't want to grow up to be an author like his parents, Sy Montgomery and Howard Mansfield.

He doesn't want to write books about animals or architecture.

Born with one blind eye, he can't do the herding work he was bred for.

But that's okay, because he doesn't want to do that either.

Thurber wants to sing his heart out to his favorite songs.

He wants to run like the wind with his friends.

And he wants to play fetch.

He *really* wants to play fetch.

Can someone, anyone, *please* throw the stick?

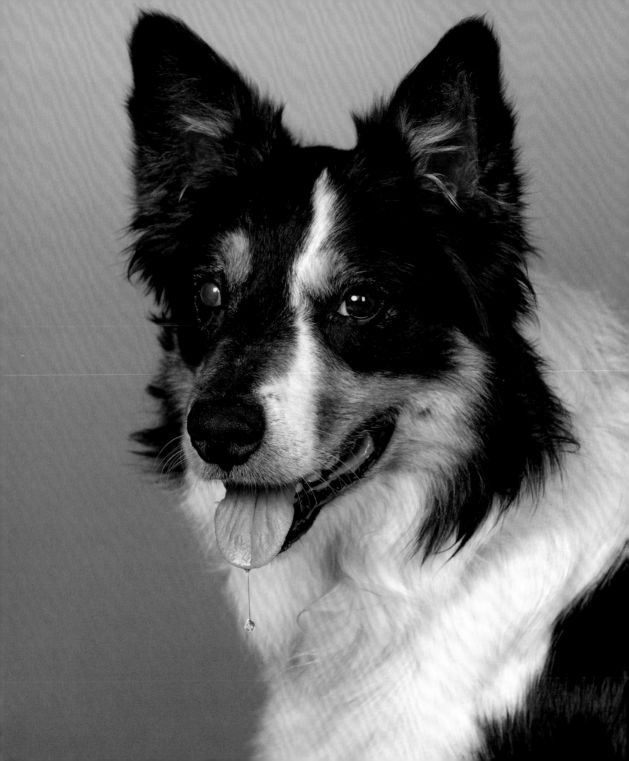

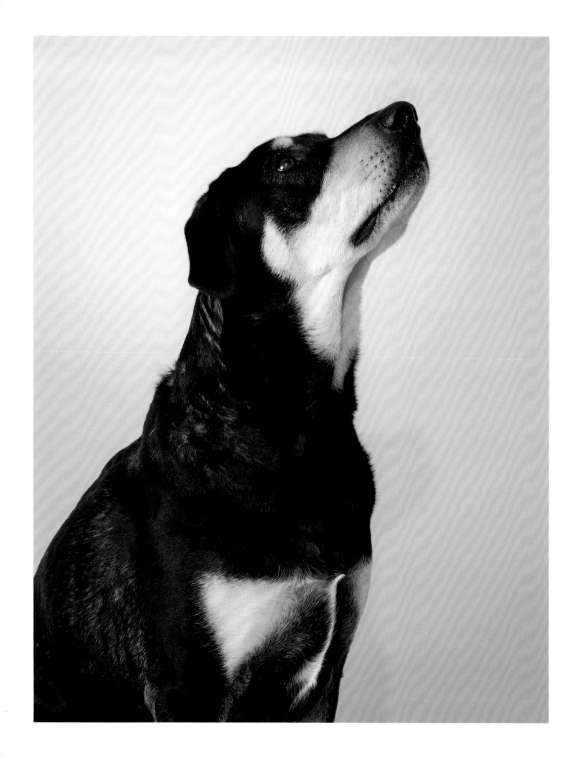

Eddy

MUTT

It was Eddy's second night in her home on the grounds of the Natick Community Organic Farm, and her new mom, Abby, rolled over, trying to ignore her loud barking. As the yelps increased in intensity, the farm's sleepy caretaker grudgingly left her warm bed and plopped down on the couch to soothe the pup she'd just rescued. For a moment Eddy fell silent. That's when Abby heard an unmistakable crackling sound. Pressing her face against the windowpane, she squinted through the black, windy night and saw a faint orange glow growing bigger and brighter. The two-hundred-year-old barn was on fire, and it was spreading fast. Abby dialed 911 and sprang into action.

By the time the farm crew got outside, the fire had consumed the barn and jumped to the rabbit hutches. They worked quickly to open gates and move all the animals they could to safety. Abby ran back into the house to get Eddy just as flames laced up its side.

It seemed like hours had passed, but it had been only a few minutes. With nothing left to do but wait for the fire engines and watch the growing flames cut through the dark sky, Abby, now welling with emotion, absorbed the gravity of the moment and looked over at her dog.

Eddy, the sweet brown mutt Abby had rescued only two days before, had just returned the favor. She'd saved the farm, the animals . . . and her life.

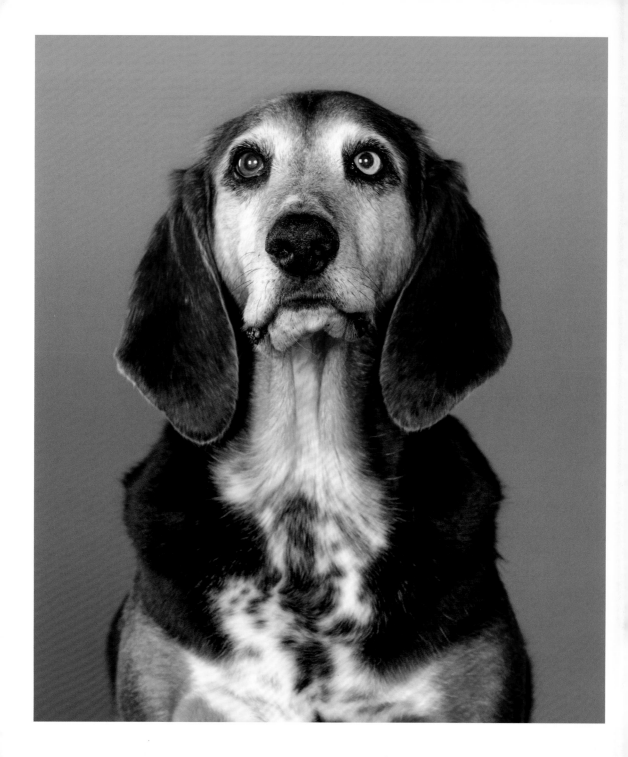

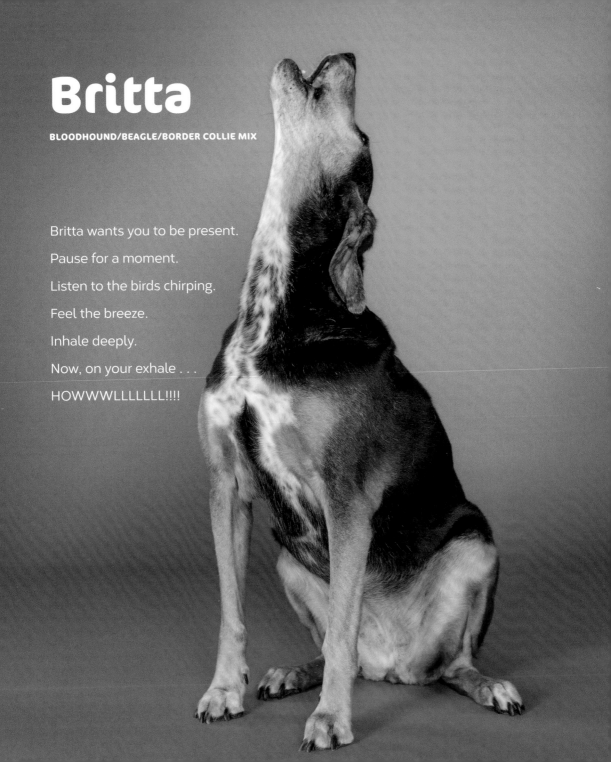

Britta

BLOODHOUND/BEAGLE/BORDER COLLIE MIX

Britta wants you to be present.

Pause for a moment.

Listen to the birds chirping.

Feel the breeze.

Inhale deeply.

Now, on your exhale . . .

HOWWWLLLLLLL!!!!

Acknowledgments

The warmest thanks to the following:

Our agent, Maria Ribas at Stonesong, for your continued support, advice, and encouragement.

Emma Campion, Kelly Snowden, Zoey Brandt, Patricia Shaw, Jane Chinn, and everyone at Ten Speed.

Emily Scalici for your retouching expertise.

Our supportive friends, family, and neighbors, especially Sean, Sarah, Alexis, Anna, Ilana, Caroline, William, John, Steven, Amelia, Gavin, Kevin, Nancy, Rachel, Mark, Heather, Priscilla, Brett, Emily, and Mom.

Lindsay Shafer, Melissa Wisniewski, and Oliver's House Rescue, for bringing Ducky into our lives.

Most important, we couldn't have made this book without the dogs and their wonderful humans who volunteered to be part of this project. Thank you for trusting us, leaning into the chaos, and sharing your stories. We're so grateful.

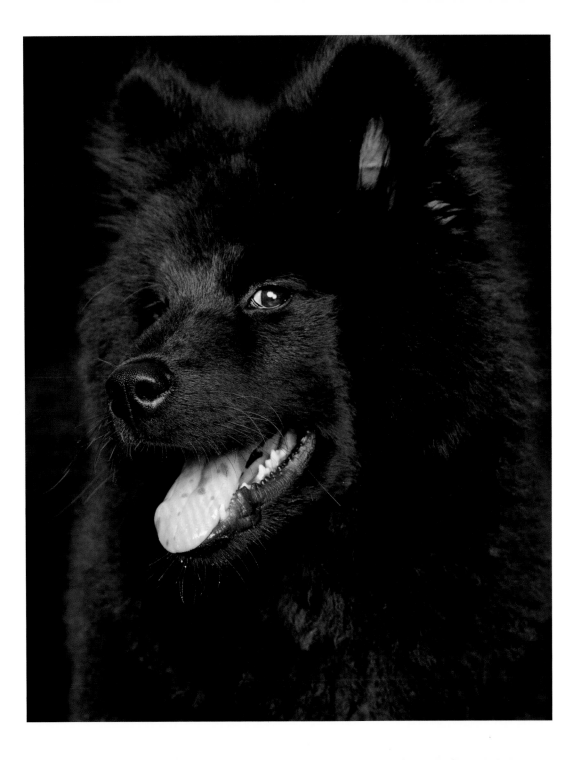

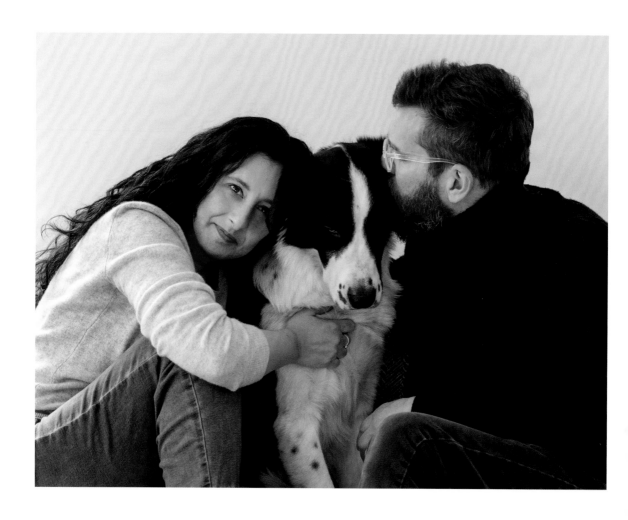

Photograph by Nell Henderson-Brown

About the Authors

Aliza Eliazarov is a photographer and the author of *On the Farm*, also published by Ten Speed Press. She's had the great honor of being a United States Postal Artist for the Heritage Breeds forever stamps released in 2021. Aliza is the former lead photographer at BarkBox and cover story photographer for *Modern Farmer* magazine. She and her husband, Edward Doty, met in photography school at the International Center of Photography and have since collaborated on several projects. Their individual work has been exhibited in the United States and abroad. They live in Kittery, Maine, with their best dog, Ducky.

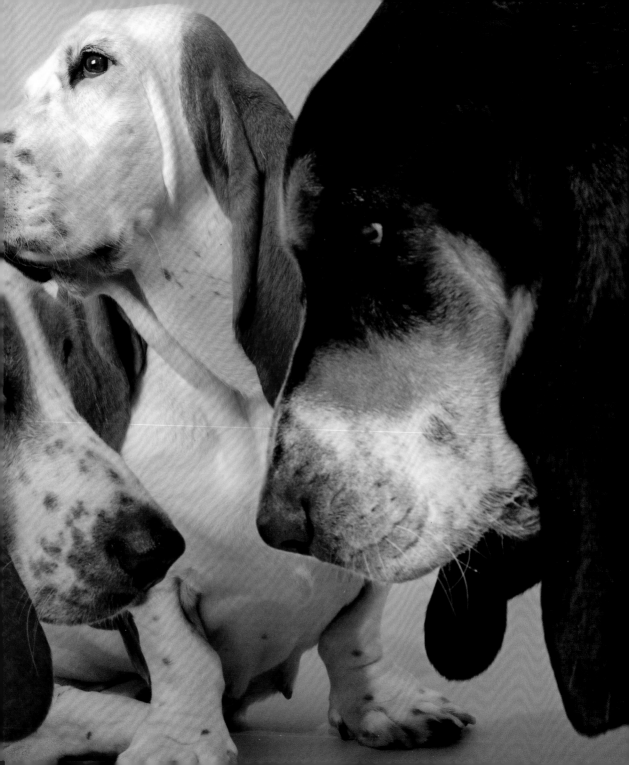

Published in the United States by Ten Speed Press, an imprint of Random House,
a division of Penguin Random House LLC, New York.
TenSpeed.com
RandomHouseBooks.com

Ten Speed Press and the Ten Speed Press colophon are registered trademarks
of Penguin Random House LLC.

Typefaces: Jonathan Hill's Corbert and Evert Bloemsma's Cocon

Library of Congress Cataloging-in-Publication Data
Names: Eliazarov, Aliza, 1973—author, photographer.
Title: The best dog : hilarious to heartwarming portraits of the pups we love /
 Aliza Eliazarov with Edward Doty.
Description: First edition. | California : Ten Speed Press, [2023]
Identifiers: LCCN 2022056797 (print) | LCCN 2022056798 (ebook) |
 ISBN 9781984861252 (hardcover) | ISBN 9781984861269 (ebook)
Subjects: LCSH: Dogs—Pictorial works. | Photography of dogs.
Classification: LCC SF430.E43 2023 (print) | LCC SF430 (ebook) |
 DDC 636.70022/2—dc23/eng/20230119
LC record available at https://lccn.loc.gov/2022056797
LC ebook record available at https://lccn.loc.gov/2022056798

Hardcover ISBN 978-1-9848-6125-2
eBook ISBN: 978-1-9848-6126-9

Printed in China

Acquiring editor: Kelly Snowden | Project editor: Zoey Brandt
Production editor: Patricia Shaw
Designer: Emma Campion | Production designer: Mari Gill
Production and prepress color manager: Jane Chinn
Prepress color assistant: Claudia Sanchez
Photo assistant: Edward Doty | Photo retoucher: Emily Scalici
Copy editor: JoAnna Kremer | Proofreader: Kim Lewis
Publicist: Lauren Chung | Marketer: Joey Lozada

10 9 8 7 6 5 4 3 2 1

First Edition